Copyright 1991 High Museum of Art
All rights reserved
Published 1991 High Museum of Art
Atlanta, Georgia
Distributed by the
University of Washington Press
Seattle and London

Designer: Jim Zambounis, Atlanta
Editors: Kelly Morris, Margaret Miller, Amanda Woods
Typesetter: Katherine Gunn
Printer: Balding + Mansell International Ltd.
    Great Britain

Library of Congress No. 91-75675
ISBN 0-939802-69-4

Cover: Cat. 51. *Chinese Restaurant*, 1915
    Oil on canvas, 40 x 48 inches
    Collection of the Whitney Museum of
    American Art, New York

# MAX WEBER
## THE CUBIST DECADE
### ▪ 1910-1920 ▪

# MAX WEBER
## THE CUBIST DECADE
### ▪ 1910 - 1920 ▪

ESSAY BY
**PERCY NORTH**

INTRODUCTION BY
**SUSAN KRANE**

**HIGH MUSEUM OF ART**
ATLANTA, GEORGIA

*Max Weber: The Cubist Decade, 1910-1920* has been made possible by a grant from the National Endowment for the Arts, a federal agency, with additional support from the Members Guild of the High Museum of Art.

*Max Weber: The Cubist Decade, 1910-1920* was organized by the High Museum of Art and presented at the following venues:

High Museum of Art
Atlanta, Georgia
10 December 1991 - 9 February 1992

Museum of Fine Arts, Houston
Houston, Texas
8 March - 3 May 1992

The Corcoran Gallery of Art
Washington, D.C.
31 May - 9 August 1992

Albright-Knox Art Gallery
Buffalo, New York
12 September - 25 October 1992

The Brooklyn Museum
Brooklyn, New York
13 November 1992 - 10 January 1993

Los Angeles County Museum of Art
Los Angeles, California
18 February - 25 April 1993

# CONTENTS

# LENDERS TO THE EXHIBITION

Michael and Ginny Abrams
Addison Gallery of American Art, Phillips Academy, Andover, Massachusetts
Albright-Knox Art Gallery, Buffalo
Baker/Pisano Collection
The Baltimore Museum of Art
Mrs. James F. Bing
The Brooklyn Museum
The Corcoran Gallery of Art, Washington, D.C.
The Detroit Institute of Arts
Fogg Art Museum, Harvard University, Cambridge, Massachusetts
Forum Gallery, New York
Greenville County Museum of Art, Greenville, South Carolina
Hirshhorn Museum and Sculpture Garden, Smithsonian Institution, Washington, D.C.
Hood Museum of Art, Dartmouth College, Hanover, New Hampshire
The Archer M. Huntington Art Gallery, The University of Texas at Austin
Joslyn Art Museum, Omaha
Lionel Kelly, England
Dr. Harold and Elaine L. Levin
Mr. and Mrs. Meredith J. Long
Edith and Milton Lowenthal Collection
McNay Art Museum, San Antonio
The Metropolitan Museum of Art, New York
Minnesota Museum of Art, St. Paul
Museum of Fine Arts, Boston
The Museum of Modern Art, New York
National Gallery of Art, Washington, D.C.
New Britain Museum of American Art, Connecticut
The Newark Museum, New Jersey
Mr. and Mrs. Leonard J. Plotch, Boca Raton, Florida
Mr. and Mrs. Louis Regenstein
The Regis Collection, Minneapolis
Rose Art Museum, Brandeis University, Waltham, Massachusetts
Fayez Sarofim Collection
Michael Scharf
Sheldon Memorial Art Gallery, University of Nebraska–Lincoln

Sheldon Ross Gallery, Birmingham, Michigan
Mr. and Mrs. Harvey Silverman, New York
Dr. Eugene A. Solow
Southwestern Bell Corporation, St. Louis
Spanierman Gallery, New York
Natalie and Jerome Spingarn
Terra Museum of American Art, Chicago
Thyssen-Bornemisza Collection, Lugano, Switzerland
Weatherspoon Art Gallery, University of North Carolina at Greensboro
Joy S. Weber
Whitney Museum of American Art, New York
Yale University Art Gallery, New Haven, Connecticut
and six private collections

# FOREWORD

There were independent individuals among the American artists who went to Europe around the turn of the century. At home, realist conventions no longer held the attention of the bolder young painters. They found in post-impressionism a freedom of expression and new possibilities for pictorial organization previously unimagined in American studios.

Max Weber was among the early modernists who discovered in Cézanne an entirely new concept of pictorial space and the dynamic interrelationship of forms. Weber's experience as a Matisse student showed him how color could become a vehicle for these relational elements in painting. During the decade of the teens, cubism was the logical form of Weber's art, and it is the process of his artistic exploration during that time which is the subject of this exhibition.

Max Weber has long been acknowledged as a leading early modernist in American art, but his work has not been shown often since the Second World War. The idea of presenting Weber's contribution as an American cubist is timely, with the revived art historical interest in cubism as a fundamental factor in modern art.

Susan Krane, the High Museum's curator of twentieth-century art, has collaborated with Percy North, the principal Weber scholar, in examining Max Weber's early career as a mature painter and in selecting the works for this exhibition. It is gratifying that their project will be seen in four other major cities besides Atlanta.

Gudmund Vigtel
Director Emeritus
High Museum of Art

# ACKNOWLEDGEMENTS

An exhibition of such specific focus is possible only with the goodwill and commitment of many individuals. We are first and foremost grateful to the many museums and collectors who have generously parted with their works for the tour and given audiences around the country the opportunity to see them in this historical context. Robert Fishko and Bella Fishko of Forum Gallery were instrumental in helping us research and secure loans and exceedingly gracious in lending works from the gallery's holdings. Our special thanks go to collectors Natalie Davis Spingarn and Dr. Nathan Davis for their longstanding commitment to Weber's work, and to the late Helen Miller Obstler (the daughter of Nathan and Linda Miller, Weber's first major patrons), who assisted Percy North's research for over twenty years and whose warm friendship is a fond memory. For their additional assistance with our loan requests, we are grateful to D. Scott Atkinson, curator, and Jayne Johnson, registrar, Terra Museum of American Art, Chicago; Dr. Anselmo Carini, associate curator of prints and drawings, Art Institute of Chicago; Andrew Crispo; Rita Crouse; Erica E. Hirshler, Museum of Fine Arts, Boston; Pam Johnstone, Hirschl & Adler Galleries, Inc.; Myron Kunin and Vicki Gilmer, Regis Collection, Minneapolis; Meredith Long and Company; Barbara Mathes, Barbara Mathes Gallery; Elizabeth Moore; Nat Owings, Owings-Dewey Fine Art; Richard York Gallery; Salander-O'Reilly Galleries; Sotheby's; Carey Ellis Company; Suzanne Vanderwoude, Vanderwoude/Tananbaum Gallery; Charlotte Wellman; and Mary Zlot & Associates.

Joy S. Weber, the artist's daughter, enthusiastically participated in many aspects of this project, which would not have been possible without her support and involvement. Joy generously gave us access to the family archives, her father's papers and library, and is a major lender to the exhibition as well. Her help with xeroxing rare materials and arranging for photography went way beyond the call of duty; we are lucky she is such a careful and organized keeper of her father's memory. We thank Joy and Elena Lamb for their patient assistance, and for their warm and gracious hospitality.

We are particularly grateful to Jeffrey Peabody of Forum Gallery, New York, for being so helpful with our seemingly endless research queries. Additional information was kindly provided by Elizabeth Agro, The Metropolitan Museum of Art; Jeffrey Aronofsky, National Yiddish Book Center; Atlanta-Fulton Public Library; Alex Baker, Philadelphia Museum of Art; Ann Berent-Johannsen, Glass Art Gallery Inc.; Ruth Bohan; Fred Brandt, The Virginia Museum of Fine Arts; Ron Cahill, Santa Fe East; Piers Connell; William Cuffe, Yale University Art Gallery; Rosemary Cullen, John Hay Library, Brown University; Elissa M. Curcio, The Carnegie Museum of Art; Barbara J. Dawson, The Corcoran Gallery of Art; Bonnie Favin, Montgomery College Library; Richard L. Feigen and Bridget Schoonderwoerd, Richard L. Feigen & Co.; Margaret Fraser, Art Services International; Victoria Garvin, The Museum of Modern Art; Patti A. Hager, National Museum of American Art; Tom Hinson, The Cleveland Museum of Art; Kari Horowicz, Albright-Knox Art Gallery; Althea Huber, The Art Institute of Chicago; Louise Kale, Muscarelle Museum of Art; Liza Kirwin, Archives of American Art; Audrey Koenig and Gary A. Reynolds, The Newark Museum; Lisa Leary, Rose Art Museum, Brandeis University; Pat Lynagh, National Museum of American Art/National Portrait Gallery; Stephanie Margolin, Pennsylvania Academy of the Fine Arts; Patricia Nardelli, New Jersey State Museum; Roger North; Laird Ogden, The New York Historical Society; Rachael Ranta, Transco Energy Services; Merrill Schleier; Jamie Smith, Terra Museum of American Art; Carol Stanbury, Detroit Institute of Arts; John J. Trause, The Museum of Modern Art Library; and Dominique H. Vasseur, The Dayton Art Institute. Dr. Barbara Wolanin's suggestions on preliminary drafts of the essay and the technical assistance of Dr. Beverly Elson, Frank Gray, Daniel Rainey, and Dr. Alan Tidwell were especially critical.

We are very pleased that this exhibition will be seen at the Museum of Fine Arts, Houston; The Corcoran Gallery of Art, Washington, D. C.; the Albright-Knox Art Gallery, Buffalo; The Brooklyn Museum, Brooklyn; and the Los Angeles County Museum of Art, institutions with very distinguished histories in the field of American modernism. We thank our colleagues, Peter C. Marzio, director, and Alison de Lima Greene, associate curator, at the Museum of Fine Arts; Dr. David Levy, director, and William B. Bodine, Jr., assistant director for curatorial affairs, at The Corcoran Gallery of Art; Douglas Schultz, director, and Cheryl Brutvan, curator, at the Albright-Knox Art Gallery; Robert T. Buck, director, and Linda Ferber, chief curator, The Brooklyn Museum; and Earl

A. Powell III, director, and Ilene Fort, associate curator, American art, at the Los Angeles County Museum of Art, for their enthusiastic support of this show and their ready assistance with the details of its circulation.

This project was truly a team effort, and we are endebted to the entire staff of the High Museum for their participation. Gudmund Vigtel, director emeritus, encouraged this exhibition from its inception, and his support was carried on by Ned Rifkin, director. Carrie Przybilla, assistant curator of twentieth-century art, and Joy Wasson, curatorial assistant, assisted with many aspects of the organization of this exhibition and publication with their usual good nature, wit, and tenacity in the face of tight deadlines and many other pending projects. Intern Shondra Thomas prepared preliminary drafts of the documentation and bibliography, and summer interns Gloria Alvarez, Alison Poarch, and Lynn Wolfe further helped with verification of information and made countless runs to the library for us. It was a pleasure to work with Jody Cohen, associate registrar; we thank her for her careful attention to detail and for so graciously keeping us on track. We are also grateful to the following staff members for their particular efforts on this show: Anna Bloomfield, curatorial assistant; Colleen Callahan, membership manager; Mickey Clark, art handler; Gene Clifton, art handler and carpenter; Sue Deer, director, marketing and communication; Ellen Dugan, chief curator of education; Evan Forfar, art handler; Leah Greenberg, development associate, grants; Marjorie Harvey, manager of exhibitions; Mike Jensen, art handler; Maureen Marks, merchandise manager, museum shop; Jack Miller, librarian; Larry Miller, art handler; Joy Patty, curator of education, adult programs; Pam Riddle, director of development; Nancy Roberts, chief art handler; Betty Sanders, development associate, corporate support; Suzanne Stedman, manager of special events and group sales; Teri Stewart, graphics technician; Ricky Thomas, accounting manager; Jim Waters, exhibition specialist; Ann Wilson, public relations associate; Amanda Woods, assistant editor; and Paulette Zeller, curator of education, student and family services. This catalogue was edited by Kelly Morris, publications manager and editor, and Margaret Miller, associate editor, whom we thank for their care in seeing through its production. It was again a pleasure to work with designer Jim Zambounis, who approached this project with his usual sensitivity and eagerness for the art and its historical context.

We are especially grateful for the generous support of the National Endowment for the Arts, without whose commitment an exhibition of this depth would not have been feasible.

Susan Krane
Curator of Twentieth-Century Art
High Museum of Art

Percy North
Guest Curator
Associate Professor of Art History
Montgomery College, Virginia

This catalogue is dedicated by Percy North to the memory of Helen Miller Obstler (1898-1990).

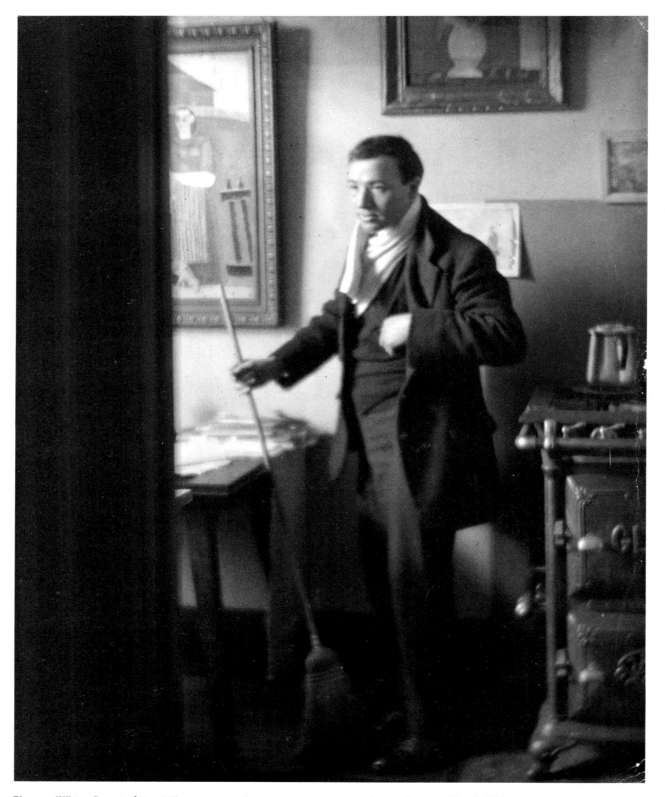

Clarence White, *Portrait of Max Weber*, ca. 1913, platinum print, 9½ x 7½ inches, collection of Joy S. Weber.

# INTRODUCTION

On the auspicious occasion of his exhibition at the Museum of Modern Art in 1930, one front-page headline read, "Weber, Once Held 'Lunatic,' Given Big Show."[1] It was reluctant, indeed almost damning, praise, particularly considering the magnitude of the honor at hand, yet it epitomizes the vicissitudes faced by Weber and his fellow American modernists. In fact, Weber had by that time received substantial recognition within the small coterie of the art world and was respected for his knowledge, ideas, and experimentations. Very early in his career, during his first New York show, he was honored with the patronage of Arthur B. Davies and earned the interest of the esteemed Robert Henri. In mid-career, he became the first American artist celebrated with a retrospective at the Museum of Modern Art (held in their inaugural year, no less), and the second so recognized by the Whitney Museum of American Art. Yet his reception by the popular press was mixed at best. Even in 1930—over fifteen years after their creation—Weber's still-unfamiliar abstractions were mocked and derided, as too was the cause of "advanced" art:

> The . . . canvases range from tortured expressions of an ingrowing mind and a groping hand to vapid grotesqueries . . . or dull arrangements of women's bodies—or rather the bodies of an arthritic race of his own conception. . . . In an age of egotism—where painters bow to their souls first and their art afterwards—Max Weber is outstandingly selfish.[2]

Such biting period criticism indeed seems a humorously bombastic historical curiosity today. However, the public's derogatory and disheartening response to new artistic expressions (which to this day has an unfortunately familiar ring) often negatively affected the American artistic personality; Weber's career, for example, was marked by lingering bitternesses. The vitriolic judgement of the masses became—in the most confident times—a strange kind of validation, a badge of avant-garde courage. A few months after the infamous Armory Show of 1913 (which drew unprecedented attendance as well as public ridicule), Weber wrote about his solo exhibition at the Newark Museum: "As for my pictures on view, I only wish I could have more advanced ones; but, as you said, these will do splendidly to begin 'trouble' with."[3]

With his break from the close-knit Stieglitz circle in early 1911 and withdrawal from the prestigious and pivotal Armory Show two years later, Weber found himself caught between the politics of the art world and the public's hostility to advanced art. Barely in his thirties and one of the most knowledgeable and forward-thinking artists of his generation, he saw his predicament as undeserved and disappointing. Yet Weber's plight was hardly atypical, for contemporary artists in America were faced with the reality of inherent conservatism and a national pragmatism that left little respect for their aesthetic endeavors. The climate was quite unlike that of Europe, in whose venerable artistic history and values Weber was schooled. At the height of his exuberance, Weber faced the chasm between his aspirations and those of an uninitiated public who tended to see such pictorial exploration as a frontal attack. Morality, not just aesthetics, was at stake. In 1915, one reporter summed up the outrage: "Art courage is as descried to-day as scientific fervor was in the Middle Ages. Yet without the spirit of the inventor what is art?"[4]

Disparagement and isolation cut deep and continually countered the unbridled optimism Weber and his colleagues had held for a new art. At the start, it was an enthusiastic time, fueled by the pioneering spirit of experimentation. Weber exulted, in late 1912:

> This is a wonderful age we are living in now. Everyone has more creative liberty. The creative mind finds new ways and stops at no law laid down by, or piled upon us by lesser or non-creative minds. . . . It is great to live now! It is harder, but what of that? The hunger we have now! This new embrace of the universe. This great blending of various forms of expression.[5]

For Weber, the vast, exciting territory of this modern age was hard won and cherished. He had emigrated at the age of ten from Bialystok, Russia, a good-sized town but one in which water was still drawn from neighborhood wells. Weber vividly remembered his amazement when he saw his first electric lights, onboard the ship bound for the United States.[6] At the age of sixteen, against his parents' wishes, he ventured out of the confines of Orthodox Jewish Brooklyn to study art at the Pratt Institute. Weber subsequently journeyed to the far-flung, unfamiliar locales of Lynchburg, Virginia, and Duluth, Minnesota, in pursuit of teaching opportunities that would earn him the money to set out for Paris, his ambitions inspired by the expansive teachings of Arthur Wesley Dow. Weber secured his American citizenship shortly before embarking

for Europe, at the age of twenty-four.[7]

Afoot in Europe, Weber was an eager and highly motivated student, equally intrigued by historic masterpieces and by the alternative artistic movements then challenging Beaux-Arts traditions. He arrived in the fall of 1905, when the Fauves were the outrage of the Salon d'Automne. Within the first year of his sojourn, he exhibited at the Salon des Indépendants and the Salon d'Automne, and began his extensive travels to study and pay homage to the great monuments of western art. He attended the salon of Madame Delaunay (the mother of painter Robert Delaunay), where he met Jean Metzinger and Henri Rousseau. Although nearly forty years his senior, Rousseau became his fast friend: together they visited the great Cézanne retrospective of 1907 at the Petit Palais. Through Jules Flandrin, he met Guillaume Apollinaire and Albert Gleizes; at Leo Stein's, he encountered Picasso, whom Weber soon introduced to Rousseau. He saw the latest works of Matisse and Picasso (whose art remained a touchstone for Weber throughout his career), as well as folios of Japanese prints at the Steins' erudite Saturday evening salons, which he frequented:

> This salon was a sort of international clearing house of ideas and matters of art, for the young and aspiring artists from all over the world. Lengthy and involved discussions took place, with Leo Stein as moderator and participator. Here one felt free to throw artistic atom-bombs, and many cerebral explosions did take place.[8]

Weber assumed an active role within the circle of expatriates. He helped start a class under the tutelage of Henri Matisse and was one of the founding members of Edward Steichen's New Society of American Artists, along with Alfred Maurer, Patrick Henry Bruce, and John Marin. He was introduced to African sculpture by Matisse and began to collect Japanese prints, no doubt in homage to Dow's teachings on Orientalism.[9] In this highly sophisticated European avant-garde milieu, Weber's associations were particularly rich, and a far cry from his experiences in Brooklyn or in Duluth.

Weber ran out of money in late 1908. His mentor and comrade, Rousseau, organized a farewell soirée for him, attended by Picasso, Marie Laurencin, and Apollinaire, among others. Two days later, Rousseau accompanied him to the train station and sent him off with the prophetic words "N'oubliez pas la nature, Weber." Weber returned to New York a new and fervent initiate into the heady realm of modernism, only to discover a cultural "North Pole. . . . Just bleak, nothing."[10] He found himself relegated to an environment he considered infinitely inferior to that of Paris, which he had left so reluctantly.

Weber's expectations were forever colored by his European experience; the necessity of redefining his art in American terms affected his attitude for the remainder of his career. As a result, a difficult ambiguity and irascibility pervaded his art, his writings (which are at times proselytizing), and his character. Weber struggled tenaciously to succeed in his own right

as a pioneer of modernism in America, only to be greeted with bemusement and hostility by the critics and to end up self-exiled from the one group sympathetic to his cause following his fray with Stieglitz. Ironically, after European advanced art was introduced to wider audiences through the Armory Show—some four years after his return to America—Weber was continually eclipsed by his former associates:

> Building on each successive stylistic adventure, he still manifests in this work of his maturity echoes of the early impact of the School of Paris. Especially in the still-lifes one discerns the coherence of the cubists and the simplified decorative idiom of Matisse. In the figures, particularly the nudes, are reminders of the squat nudes of Picasso in 1907. . . . But all this is evidence of the way a master can assimilate and transform the vision of his day into a personal style. Moreover, Weber's art is predicated on a very personal emotion, one undisguised and full of sentiment and overtones, not unlike that quality in music which is known as "schmalz." It is saved from banality and sentimentality, however, by control and, above all, by Weber's very great mastery of painting.[11]

However disappointing it was artistically, the New York Weber returned to was nonetheless amazingly unlike the city he left in 1901. The subway system was expanding rapidly; by 1910, there were over one hundred miles of subway track. Weber avidly watched the excavation of the 7th Avenue line —using carts and ponies—and drew the phenomenal sight repeatedly.[12] Downtown Manhattan sprouted a growing number of tall buildings, paeans to progress and American commerce. In 1908, the Singer Building rose; in 1909, the Metropolitan Tower and Liberty Tower. By 1913, the much-touted and much-advertised Woolworth Building dominated the skyline at fifty-five stories, to be challenged just two years later by the massive (if only forty-one-story) Equitable Building.[13] This burgeoning modern New York—with its speed, height, and new perceptions—was ever the more impressive given the impact of virtually eight years' absence.

Weber gradually adopted the city and its dynamic spirit as his subject, no doubt propelled by his interaction with photographers Alfred Stieglitz[14] and Alvin Langdon Coburn, as Percy North details in her essay. Weber's relationship with Stieglitz was brief and tense—a clash of will, ego, and authority; it lasted only from mid-1909 through January of 1911. Regardless of their angry parting of ways, Weber continued to profess his great admiration for Stieglitz's photography and considered it some of the best of the time. Stieglitz's photographs of New York (dating back to the early 1890s) had been pivotal to the development of the city as an iconic image and to the acceptance of its emblematic potential. Until late in the decade, Stieglitz romanticized the urban phenomenon. At one point, he even declared his wish to have his ashes scattered from the heights of the famed Flatiron (Fuller) Building on

Madison Square,[15] a powerful subject of his work as well as that of Coburn, Steichen, and Marin. Stieglitz's and Coburn's most inspirational images, such as Stieglitz's *The City of Ambition*, 1910 (fig. 13),[16] and Coburn's *New York*, 1910, were disseminated through *Camera Work*, to which Weber also contributed.

Shortly after the modern cityscape gained wide acceptance as a suitable artistic subject, Sadakichi Hartmann, writing for *Camera Work* in 1903, declaimed the Americanness of the skyscraper. The tall building, he professed, symbolized the nation's liberation from the confines of the past and paralleled the very character of America, with its "forceful vitality of youth, adolescent in its tentative desire for beauty."[17] His description applied equally to the young painters who turned their eyes toward the intoxicating grandeur of the modern age and grappled for appropriate motifs and styles to convey this new beauty. For Max Weber, returned full of enthusiasm from the art camps of Europe, the vitality and restlessness of the fledgling skyscraper city matched that of the modernist quest. The exuberance of the Americans was validated by avant-garde French artists who arrived in New York during the war years. Picabia expounded in 1913, "Your New York is the cubist, the futurist city. It expresses in its architecture, its life, its spirit, the modern thought. You . . . are futurists in word and deed and thought."[18]

Weber's principal comrade in his aesthetic taking of the city was photographer Alvin Langdon Coburn, whom he met in 1910. They became close friends, and continued a frequent cross-Atlantic correspondence for years after Coburn settled permanently in England in 1912. Coburn had turned his lens on urban subjects as early as 1906 in pictorialist, light-suffused images of New York and London. Tellingly, the visionary writer H. G. Wells contributed the introduction to Coburn's *New York*, 1910, a book of twenty heroic and pictur-esque images, including the impressive giants the Singer Building, the Park Row Building, the Flatiron Building, and the Metropolitan Tower. Coburn rhapsodized about his subject:

> As I steamed up New York harbor the other day on the liner that brought me home from abroad I felt the kinship of the mind that could produce those magnifi-cent Martian-like monsters, the suspension bridges, with that of the photographer of the new School. The one uses his brain to fashion a thing of steel girders, a spider's web of beauty to glisten in the sun, the other blends chemistry and optics with personality in such a way as to produce a lasting impression of a beautiful fragment of nature. The work of both, the bridge-builder and the photographer, owes its existence to man's conquest over nature.[19]

As he later exclaimed of his craft, "We are comets across the sky of eternity."[20]

Weber and Coburn influenced and challenged each other, regardless of the differences in their media and the dis-similarity of their styles at the time. Weber contributed his understanding of modernist aesthetics, Coburn his enthrall-ment with the city. Weber initially felt estranged from the writhing, brashly capitalistic city. His fresh perspective on New York, and his most aggressive interpretations of the city, coincide with the years of his dialogue with Coburn and parallel the zenith of urban fever among the 291 circle.[21]

Weber and Coburn frequently compared the city and nature, a dichotomy they ultimately had difficulty reconcil-ing. After his return from the Grand Canyon in 1911, Coburn decided to photograph the man-made canyons of New York and set out, with Weber, to see "New York from Its Pinnacles" (the title of his subsequent exhibition in London in 1913). This colossal perspective of New York was awing: "How romantic, how exhilarating it is in these altitudes," Coburn exclaimed.[22] Their forays are documented in Weber's *New York (The Library Tower from the Singer Building)*, 1912 (cat. 27, p. 53), and Coburn's *The House of a Thousand Windows*, 1912 (fig. 11), which he referred to as his "cubist fantasy."[23] As North and others have noted, both images probably depict views from the top of the popular Singer Tower (nicknamed the "Singerhorn"), to whose observatory one could ascend for a small fee.[24] Their artistic interplay was often less overt. Coburn's famous *The Octopus*, 1912 (fig. 10), a view of Madison Square Park taken from the top of the Metropolitan Building, is echoed in Weber's *New York*, 1913 (cat. 38, p. 57). Similarly sinuous forms radiate from a circle at center right (reiterated by the scenic pathways glimpsed at the bottom left of Weber's paint-ing), and the frame is likewise cut by a raking diagonal at top left. Critic Henry McBride wrote of Weber's picture:

> Something sinuous, a great worm or serpent, twists "its slow length along" this curious picture. This serpent starts in the picture from a spot that, since we know the title of the picture, we can guess to be City Hall, and winds in and out of the whole city. It is not, however, what you think it is. It is, the artist explains, merely the "Subway influence."[25]

Weber's iconography was thus fed by Coburn's photographs. The ever-present steam and smoke of Coburn's images—evidence of technology and the workhorse of the city—reappear juxtaposed against the clouds of nature in Weber's composite views, such as *New York*, 1913 (cat. 38, p. 57), *New York*, 1912 (cat. 26), and *New York (The Liberty Tower from the Singer Building)*, 1912 (cat. 27, p. 53). As Weber described, in "On the Brooklyn Bridge" (p. 96), a "poem" he later sent to Coburn:

> I stood and gazed at the millions of cubes upon billion of cubes pile upon pile, . . . befogged chimney throats clogged by steam and smoke—all this framed and hurled together in mighty mass against rolling clouds. . . .[26]

A subtext of these works is the uneasy interface of man and nature (e.g., smoke vs. clouds), and man's disquieting "con-quest over nature," to borrow Coburn's words. Although Coburn transposed his awe for the Grand Canyon to the skyscraper city—and pictured the creations of man as rival to

those of nature—he recognized the flip side of this technological spectacle. He despaired at the daily plight of the inhabitants of the streets below, noting the difference "as I become one of the grey creatures that crawl about like ants at the bottom of its gloomy caverns."[27] Similarly, Weber at times darkly "thought of this pile throbbing, boiling, seething, as a pile after destruction. . . ."[28] In the rapidly changing city, the powers of creation and destruction stood unsettlingly side by side. Regardless of such persistent undercurrents of doubt, Weber nonetheless later effusively recalled the city's visual delight, "Altogether—a web of colored geometric shapes, characteristic only of the Grand Canyons of New York at Night."[29]

With its massive rectilinear skyscrapers and gridded streets, New York proved the perfect subject for Weber's interest in the poetics of geometry and rhythmic design. Yet Weber saw the city not simply as analytical, aesthetic fodder, but in spiritual terms. In many ways, he carried on the nineteenth-century American traditions of Whitman, reflected in *Manahatta*, 1881, the poet's ode to the "Numberless crowded streets, high growths of iron, slender, strong, light, splendidly uprising toward clear skies. . . ."[30] Weber's writings reveal the near religiosity of his attitude, epitomized by his entreaty "OH Sun," in the surprisingly archaic language of *Cubist Poems*:

> OH sun to thee it is to make all visible,
> Under thy rays of light
> Lies this great city of cubic form—New York.[31]

Weber often anthropomorphized the city in his writings: windows become eyes, chimneys the nostrils of the metropolis, as for example in "Eye Moment" (p. 97). Perhaps in part due to his Orthodox religious background as well as the influence of critic Charles Caffin,[32] the material world was for him always tied to mankind and the spiritual realm, a belief that indeed gave justification and further legitimacy to the vocation of painting. When musing in the early morning on the din and industrial scene from "On Brooklyn Bridge," Weber was "lulled into calm and meditation" and piously moved: "Two worlds I had before me the inner and the outer. I never felt such. I lived in both!"

Weber habitually associated these interior and exterior worlds, and linked earthbound emotions with his formal ideals. "Two crouching figures of women dwelling and brooding in a nether or unworldly realm. . . . The conception and treatment spring from a search of form in the crystal. . . ,"[33] he explained of *The Geranium*, 1911 (cat. 13). This comment points to his growing interest in the fourth dimension, an idea much discussed in popular literature as well as art circles of the day.[34] Weber was most likely introduced to such concepts through Apollinaire, Metzinger, and Gleizes, whose theories were germinative when he was friendly with them in Paris around 1908. After he returned to the United States, Weber wrote "The Fourth Dimension from a Plastic Point of View" for *Camera Work* in 1910 (p. 95); it was the first treatise on the

fourth dimension in visual art, to which Apollinaire closely referred in his pivotal text *Les Peintres Cubistes*, 1913.[35] Through his article and his associations, Weber initiated American art circles to the sophisticated theory, which became a frequently debated topic and was often combined with a variety of occult concepts, as was the tendency at Mabel Dodge's salon. Of interest to personalities as diverse as Morton Schamberg, Gertrude Stein, and Arthur Dove, the fourth dimension continued to intrigue artists for decades. With the popularization of Einstein's theory of relativity (which received great attention when he embarked on an American lecture tour in 1920),[36] theories of the "fourth dimension" encompassed concepts of time as well as space.

For the European modernists, the fourth dimension was primarily tied to the expression of physical sensation and to complex, non-perspectival spatial perception. For Weber, however, the fourth dimension pre-existed as "the consciousness of a great and overwhelming space magnitude in all directions at one time. . . . It is somewhat similar to color and depth in musical sounds. It arouses the imagination and stirs emotions. It is the immensity of all things."[37] Weber saw the fourth dimension not solely as a model for a cubist, stylistic dissection and re-ordering of form; his fourth dimension was rather the inherent, indeed divine, element reflected by the subjects of nature. The conveyance of this spiritual component (or its aura) gave true import to pictorial renditions of the physical world. The metaphysical and the material spheres were thus inextricable:

> The ideal or visionary is impossible without form: even angels come down to earth. By walking upon earth and looking up at the heavens, and in no other way, can there be an equilibrium. The greatest dream or vision is that which is regiven plastically through observation of things in nature. . . .

Weber's fourth dimension was not a pseudo-scientific twilight zone related to the spatial "plasticity" of modernism. It was rather *the* essential mystical component found in all art, and he saw no contradiction in pointing to classical examples like the Acropolis or to the work of Giotto.[38] In his *Essays on Art*, Weber expounded on this transcendental power: "A work binds its maker to the universe. . . . It seems to me one of the most important functions of our daily breathing or living, this spiritual communion with objects—with works of art. We pray in belief, but this art consciousness or plastic consciousness is belief in proof. The reality of art is its mystery."[39]

Not surprisingly, Weber soon strove to locate in abstract painting "a more human art." He in fact explained his shift to figurative subjects and a more representational style at the end of the decade as a return to "the works of God themselves."[40] Weber's unsuppressible spirituality and renewed desire for humanitarianism is evident by 1917, in the domestic interiors and familial scenes begun shortly after his marriage. As he explained of his syncopated, decorative late cubist works, like *The Cellist*, 1917 (cat. 61, p. 49): "The human touch, the spirit and charm of music was cherished and vested in the plastic."[41]

16

In the decade of his greatest experimentation, Weber approached art with an earnest, scholarly mind and an impassioned fervor for the elevated cause of modernism. His persistence and his at times argumentative intellectualism were off-putting to some, as related in Temple Scott's characterization of Weber in the anecdotal "Fifth Avenue and the Boulevard Saint-Michel."[42] As revealed in his writings, his teaching, and his works, Weber had a sophisticated and synthetic sensibility, and prided himself on his learnedness. He assiduously explored new artistic ideas and styles, yet inevitably soon amended them. For example, although he might well have seen Picasso's early cubist works, he addressed cubism only some years later, prompted by Gelette Burgess's article "The Wild Men of Paris," published in May of 1910. As postulated by Percy North and John Lane,[43] Weber adhered literally to George Braque's prescriptions (cited in Burgess's article) that the portrayal of any object required three distinct viewpoints. Whereas Braque amalgamated these viewpoints into a single cubist figure, Weber typically presented several distinct figures as if seen sequentially rather than simultaneously. Interestingly, Weber also imparted to each an emotional attitude—e.g., reposing, forthright, demurring—quite foreign to the objectivist dictates of continental cubism.

Although he was a careful student, as his drawings in particular reflect, Weber easily transposed the style of cubism for his needs. His predilection for design and rhythm carried over to his cubist explorations: rarely do Weber's finished paintings display the interest in re-describing mass typical of his European counterparts. Weber tended to juxtapose rather than assimilate viewpoints, and was hesitant to explode form completely. The buildings in his city pictures usually remain intact, and even his most recombinant visions often retain anecdotal passages, as in *New York*, 1913 (cat. 38, p. 57), with its glimpses of urban scenes, smokestacks, and an airplane. In *Chinese Restaurant* [*Memory of a Chinese Restaurant*], 1915 (cat. 51, cover), for example, one can discern the faces of the diners and the architectural structure of the interior. He explained his pictorial objectives:

> On entering a Chinese Restaurant from the darkness of the night outside, a maze and blaze of light seemed to split into fragments the interior and its contents, the human and inanimate. For the time being the static became transient and fugitive—oblique planes and contours took vertical and horizontal positions, and the horizontal and vertical became oblique, the light so piercing and so luminous, the color so liquid and the life and movement so enchanting! To express this, kaleidoscopic means had to be chosen. The memory of bits of pattern were less obvious than the spirit and festive loveliness and gaiety—almost exotic movement. Therefore, the glow, the charm, the poetry of geometry was stressed. The whole picture is made even more significant by the distribution of flickers here and there in fitting place of a hand, an eye, or drooping head.[44]

Weber's humor often peeks through this academicism: the lyrical, elegantly balanced *Avoirdupois*, 1915 (cat. 50, p. 75), for example, is also a pun on the peas ("avoir du pois") on the scale.

What in hindsight may look simply like direct borrowing in Weber's work is often an extension of his independent, preliminary tendencies. His interest in forceful diagonals and the depiction of movement in space has precedents, for example, in *Dancers*, 1912 (cat. 19), with their emanating outlines. Such hesitant passages become full-blown after Weber's study of futurism, which substantiated his inclinations and emboldened his abstractions, in spite of his disregard for the politics of the movement.[45] He brilliantly adapted futurist "lines of force" and mechanistic imagery in later works such as *Rush Hour, New York*, 1915 (cat. 57, p. 62), and *Athletic Contest* [*Interscholastic Runners*], 1915 (cat. 49, p. 63), a pixilated rendition of interscholastic sports. Similarly, Weber's concentration on "color construction" and circular passages (discernible in his early New York pictures and expanded in *Color in Motion*, 1914 (cat. 45, p. 59), coincides with the rise of the synchromist movement in 1914-15 and the publication of the synchromist critic Williard Wright's book *Modern Painting* in 1915.

Weber struggled to maintain the cosmopolitan breadth he had acquired in France, and his position at the forefront of his times. With unusual adventuresomeness and curiosity, he embraced radical new ideas (often learned second-hand), practiced them, and made them his own. To some critics, this work appeared too purposeful and derivative, with "the air of studio exercises, something unseen and unfelt.'[46] Such searching, however, contributes to the momentum of Weber's art, and of much modernism. His career is characterized by his avid and energetic exploration, not by heroic surety. For example, concurrent with his cubist endeavors, he also made scenic collages that recall the naiveté and simplicity of Rousseau. Weber was not, by nature, anarchistic or bohemian and did not conform to the myth of modernist genius, like his more flamboyant European contemporaries. He was a modest, deliberate man, who sought in his art as in his life the careful balance and equilibrium about which he so often wrote. Weber was, however, intellectually rebellious and courted the most advanced aspirations of the day. As Holger Cahill declared in his monograph of 1930, "Max Weber has lived the history of modern art in America. Its search and tribulation, its rebellion against decadence, the hatreds which it aroused and its ultimate triumph are chapters in his life story. Weber is a child of the modern spirit."[47]

The optimism of the modern age and Progressive Era reforms were tempered cumulatively by many factors—the recession of 1913, the depression of 1914, and the horrifying death toll of the influenza epidemic, which baffled modern science and took over a half-million lives in America before it was over. Rising hostility among labor groups exposed the underbelly of the machine of progress and growth; as nation-

alistic sentiment increased, Congress tried to place an embargo on immigration in 1915. America's triumphant spirit, epitomized by the opening of the technological wonder of the Panama Canal in 1914, was muffled by the devastation of World War I, its unexpected cost and human tragedy, and the inflation that quickly followed the armistice. The dynamism and moral objectives of early modernism were called into question as enthusiasm for newness was tempered and the spirit of conquest abandoned.[48] By the twenties, modernity was no longer the intellectual battleground of the avant-garde and soon became the populist, consumer-oriented design style of the Machine Age.

Weber, following the mood of his environment, grew increasingly disillusioned. He had no one-person shows between 1915 and 1922, and gradually narrowed the scope of his work. He focused primarily on comprehensible, domesticated subjects and genre scenes, through which he reconfirmed, rather than reconfigured or challenged, the world around him. In his late works, Weber forsook the toughness and power of the teens for anecdotal and religious subjects that gave full play to his lyrical facilities, sentiments, and expressionist bent. Ironically, it was this later work that won Weber his popular reputation and, at long last, his livelihood as an artist in America.

SUSAN KRANE

# NOTES

1. Jerome Klein, "Weber, Once Held 'Lunatic,' Given Big Show," *The Chicago Evening Post*, March 18, 1930, 1, Weber Scrapbooks, collection Joy S. Weber. Exhibitions of work by Weber, Klee, Lehmbruck, and Maillol were held simultaneously at the Museum of Modern Art.
2. M[arty] M[ann], *International Studio* 95, no. 395 (April 1930): 76.
3. Quoted in John Cotton Dana's essay on Weber, June 20, 1913, reprinted in William H. Gerdts, Jr., "Max Weber," in *Max Weber: Retrospective Exhibition* (Newark, N.J.: The Newark Museum, 1959), 15.
4. "Current News of Art," *The Sun* (New York), Sunday, December 19, 1915, 3, Weber Scrapbooks, collection Joy S. Weber.
5. Max Weber, draft of introduction to *Exhibition of Paintings and Watercolors at The Modern School* (April 23-May 7, 1913), 1912, Weber Papers, Archives of American Art [AAA] (NY59-6), 134-35.
6. "And I was lying on my little cot, and I will never forget, I used to watch that little bulb. To me that bulb was something I couldn't understand. A little wire was like fire and gave us light! It was tremendous to me." *The Reminiscences of Max Weber*, interview by Carol S. Gruber (Oral History Research Office, Columbia University, 1958), 22.
7. Cynthia Jaffee McCabe, "A Century of Artist-Immigrants," in *The Golden Door: Artist-Immigrants of America, 1876-1976* (Washington, D.C.: Smithsonian Institution Press, for Hirshhorn Museum and Sculpture Garden, Smithsonian Institution, 1976), 24.
8. Max Weber, "The Matisse Class," manuscript of lecture at the Matisse Symposium, The Museum of Modern Art, 1951, AAA (NY59-6), quoted in *Paris and the American Avant-Garde, 1900-1925* (Detroit: The University of Michigan Museum Practice Program and The Detroit Institute of Arts, 1980), 8-9.
9. *Reminiscences*, 195-96, 199, 229.
10. Ibid., 77.
11. A.B.L., "Weber," *Art News* 46, no. 9, part 1 (November 1947): 36.
12. *Reminiscences*, 281.
13. See Erica E. Hirshler, "The 'New New York' and the Park Row Building: American Artists View an Icon of the Modern Age," *The American Art Journal* 21, no. 4 (Winter 1989): 26-45, and Merrill Schleier, *The Skyscraper in American Art, 1890-1931* (Ann Arbor: UMI Research Press, 1983).
14. Weber may have been introduced to Stieglitz through Marsden Hartley. Frank DiFederico, "Alvin Langdon Coburn and the Genesis of Vortographs," *History of Photography* 11, no. 4 (October-December 1987): 277. Weber, however, said he met Stieglitz through George Of, *Reminiscences*, 100. See Percy North, "Turmoil at 291," *Archives of American Art Journal* 24, no. 1 (1984): 12-20, for a discussion of Weber's relationship with Stieglitz.
15. Schleier, *The Skyscraper in American Art, 1890-1931*, 41, 51. See pp. 41-68 for a thorough assessment of Stieglitz's role in promoting the city as modern icon.
16. Weber later claimed to have encouraged Stieglitz to take this well-known image. See Weber interview with Peter Bunnell, September 8, 1960, Great Neck, New York, cited in Mike Weaver, "Beyond the Craft," in *Alvin Langdon Coburn: Symbolist Photographer, 1882-1966* (New York: Aperture Foundation, 1986), 38.
17. Sadakichi Hartmann, "The 'Flat-Iron' Building: An Esthetical Dissertation," *Camera Work*, no. 4 (October 1903): 40, quoted in Schleier, *The Skyscraper in American Art, 1890-1931*, 14.

18. Francis Picabia, "How New York Looks to Me," *New York American*, March 30, 1913, magazine section, 11, quoted in Schleier, *The Skyscraper in American Art, 1890-1931*, 65.

19. Alvin Langdon Coburn, review of International Exhibition of Pictorial Photography in Buffalo, *Harper's Weekly*, November 26, 1910, quoted in Weaver, "Beyond the Craft," 37-38.

20. Alvin Langdon Coburn, "The Relation of Time to Art," *Camera Work*, no. 36 (October 1911): 72, quoted in Weaver, "Beyond the Craft," 38.

21. Schleier, *The Skyscraper in American Art, 1890-1931*, 57.

22. Statement by Coburn in *New York From Its Pinnacles* (London: Goupil Gallery, 1913), quoted in Schleier, *The Skyscraper in American Art, 1890-1931*, 49.

23. Schleier, *The Skyscraper in American Art, 1890-1931*, 49.

24. Ibid., 51. The Singer Tower was also referred to as the Singer Building, as too were the Liberty and Metropolitan Towers.

25. [Henry McBride ?], "Max Weber, Cubist, Exhibits Paintings," *The Sun* (New York), January 31, 1915, Weber Scrapbooks, collection Joy S. Weber.

26. Max Weber, "On the Brooklyn Bridge," unpublished manuscript, 1912, Weber Papers, AAA (NY59-6), 136. Coburn's letter of January 1, 1914, to Weber refers to this "poem," AAA (NY69-85), 330.

27. Weaver, "Beyond the Craft," 38.

28. Max Weber, "On the Brooklyn Bridge," p. 96 of this catalogue.

29. Max Weber, annotation on *New York at Night*, 1915 (cat. 54, p. 60), for the checklist of his retrospective exhibition at the Museum of Modern Art in *Max Weber*, introduction by Alfred H. Barr, Jr. (New York: The Museum of Modern Art, 1930), 16, facsimile reprint in *Three American Modernist Painters* (New York: The Museum of Modern Art and Arno Press, 1969), 16.

30. Edward Weston and Walt Whitman, *Leaves of Grass* (New York: Paddington Press, 1942; reprint, 1970), 216.

31. Max Weber, *Cubist Poems* (London: Elkin Mathews, 1914), 21.

32. Linda Dalrymple Henderson, *The Fourth Dimension and Non-Euclidean Geometry in Modern Art* (Princeton, N.J.: Princeton University Press, 1983), 171-76. Caffin was part of the Stieglitz group and likely helped Weber edit his article "The Fourth Dimension," along with Stieglitz and J. B. Kerfoot.

33. Weber, annotated checklist in Barr, *Max Weber*, 16.

34. Linda Dalrymple Henderson, "Mable Dodge, Gertrude Stein, and Max Weber: A Four-Dimensional Trio," *Arts Magazine* 57, no. 1 (September 1982): 106-11, relates that between 1900 and 1914 alone, over twenty-five articles appeared on the subject in periodicals as diverse as *Harper's Weekly* and *Current Literature*.

35. Guillaume Apollinaire, *Les Peintres Cubistes* (Paris: Eugène Figuière et Cie, Editeurs, 1913). See Willard Bohn, "In Pursuit of the Fourth Dimension: Guillaume Apollinaire and Max Weber," *Arts Magazine* 54, no. 10 (June 1980): 166-69, for a close comparison of their texts and reference to Apollinaire's translation of Weber's article.

36. Sherrye Cohn, "The Image and Imagination of Space in the Art of Arthur Dove; Part II: Dove and 'The Fourth Dimension,'" *Arts Magazine* 58, no. 5 (January 1984): 123.

37. Max Weber, "The Fourth Dimension from a Plastic Point of View," *Camera Work*, no. 31 (July 1910): 25. All other quotes from Weber on the fourth dimension, unless otherwise cited, are from this article. See p. 95 of this catalogue.

38. See Henderson, *The Fourth Dimension and Non-Euclidean Geometry in Modern Art*, 167-82, for the most thorough discussion of Weber's theories.

39. Max Weber, "Quality," in *Essays on Art* (New York: William Edwin Rudge, 1916), 7-8.

40. Alfred Werner, *Max Weber* (New York: Harry N. Abrams, 1975), 52-53.

41. Weber, annotated checklist in Barr, *Max Weber*, 18.

42. Temple Scott, "Fifth Avenue and the Boulevard Saint-Michel," *Forum*, no. 44 (July-December 1910), 665-85, reprinted in *The Silver Age* (New York: Scott and Seltzer, 1919), 172 ff.

43. See Percy North, "Max Weber: The Cubist Decade," and John R. Lane, "The Sources of Max Weber's Cubism," *Art Journal* 35, no. 3 (Spring 1976): 231-36. Lane also relates the "square" feet of Weber's nudes from this period to Braque's comments, quoted in Burgess's article.

44. Weber, annotated checklist in Barr, *Max Weber*, 17.

45. Although the Futurists' activities (particularly their exhibition in February 1912 at Bernheim-Jeune in Paris) were widely reported in the New York papers in 1911 and 1912, it seems unlikely, based on the shifts in Weber's work and the dates of the Coburn correspondence, that he knew much of, or showed much interest in, the movement until the following year. Coburn enthusiastically informed Weber of the Futurists' activities and wrote that he had gone to hear Marinetti speak (see *Reminiscences*, 385), likely a reference to the series of readings and talks Marinetti gave in London in November 1913, the first since Coburn's return. See DiFederico, "Alvin Langdon Coburn and the Genesis of Vortographs," 274, and Dominic Ricciotti, "The Revolution in Urban Transport, Max Weber and Italian Futurism," *The American Art Journal* 16, no. 1 (Winter 1984): 47-64.

46. Sanford Schwartz, "Max Weber," *Art in America* 64, no. 8 (September 1976): 53.

47. Holger Cahill, *Max Weber* (New York: The Downtown Gallery, 1930), 1.

48. "Looking back from our vantage point at the end of the twentieth century, the decade of the Great War was in many ways a watershed in the mental framework of the American people. Before the First World War Americans viewed the unknown as something that was distinctly within their power to conquer. Nothing was insurmountable. This temper was the hallmark of their history. But the sobering experience of the war changed all that. Gone was the triumphant feelings of mastery and self-righteous certainty with which Americans had begun the decade, and which was in keeping with their past. Taking its place was an enervating character type of accommodation, glad-handing, manipulation and consumerism. Thus equipped to be led rather than to lead, the American people waited for the future." Robert Brandfon, "The Metamorphosis of American Progressivism," in *Over Here: Modernism, The First Exile, 1914-1919* (Providence, R.I.: David Winton Bell Gallery, Brown University, 1989), 9.

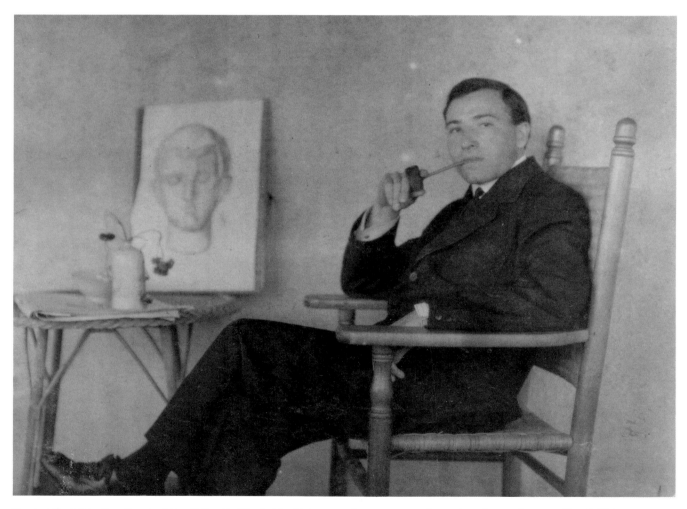

Fig. 1: Alfred Stieglitz, *Portrait of Max Weber, Deal Beach, New York,* 1910, platinum print, 3⁷/₁₆ x 4½ inches, collection of Joy S. Weber.

# MAX WEBER: THE CUBIST DECADE

## SETTING THE STAGE

Max Weber's cubist paintings are a paean to the richness of the American urban experience, a metaphor for the melting pot of twentieth-century American culture. He juxtaposed old with new, high art with popular culture, scientific discourse and engineering marvels with intimations of spiritual enlightenment and human interaction. His work reflected the diversified character of the new century through a revolutionary form of painting devised to mirror the complexities of modern life. These works are especially remarkable for Weber's assimilation of innovative formal construction, traditional fine art materials, and subjects derived from popular entertainments, modern technology, and personal experience.

On his return to Manhattan in January of 1909 after spending over three years in France, twenty-nine-year-old Max Weber embarked on a decade of creative activity that established him as America's foremost cubist painter and proved to be the apex of his career. Tentative at first, Weber looked back over his shoulder at the European modernism he had seen in Paris, but gradually evolved a personal vision.

While the first modernist works he produced in America reflected the forms and subjects of his French mentors and contemporaries—Matisse, Cézanne, Picasso, and Braque—Weber soon diverged thematically from their aesthetic to produce a body of work that glorified the drama and excitement of America in the twentieth century, using the spectacular new glittering high-rise metropolis of New York as the emblem of a new world order. Although using a formal vocabulary derived from European sources, Weber was more concerned with spiritual issues, as were his American colleagues, than his French counterparts, and unlike the French Cubists, Weber retained an interest in lively color. By 1915 Weber had developed a distinctly personal form of cubism informed by a dynamism and spirituality that reflected a particularly American consciousness.

On his return to New York, Max Weber lived in the studio of his friend Abraham Walkowitz. In the spring of 1909, with Walkowitz's assistance, Weber arranged for an exhibition of his Parisian work at the Haas Gallery, a small frame shop on Madison Avenue. A quotation from Cézanne in the brochure for the show proclaimed Weber's allegiance; the works in the exhibition, however, with their expressive colors applied in rugged undetailed shapes, reflected his familiarity with fauvism and his participation in Matisse's atelier critiques. His subjects were traditional studio fare—still lifes, nudes, and landscapes—images drawn from the academy yet recycled in slightly new ways. Weber remained firmly attached to academic subjects throughout his career, and nudes, still lifes, and landscapes remained the staples of his repertory.

When Weber departed from these historically sanctioned images, he contributed to changing the tide of art. By extending his range to include images of American popular culture viewed from the new perspective of European modernism, he helped redefine the stylistic and thematic boundaries for fine art in America. Although his Haas Gallery show was one of the first exhibitions of post-impressionist painting in America and predated an exhibition the following year in London for which the term was coined, it attracted little attention.[1] The well-known painter Arthur B. Davies purchased two pictures from the exhibition. His patronage was followed during the next several years by that of the sophisticated collectors Agnes Ernst Meyer, Mabel Dodge, Hamilton Easter Field, Etta Cone, and Alvin Langdon Coburn. At the beginning of his career, Weber was acknowledged as an artist to watch.

A critic for the *New York Morning Sun* chided Weber, writing that "Henri Matisse has been his model, perhaps idol, . . . possibly this young man may forget Paris and then he will get into the Academy (Some Day)."[2] By 1909, however, the academy had lost its allure and Weber appeared as the advance guard of the new wave that would sweep the country during the next decade. A critic for *American Art News* noted that "among the drawings are many figure studies including 'Adam and Eve' which is somewhat primitive in conception and execution."[3] Such simplified figures with awkward poses and planar construction, which the critic found "primitive," characterized Weber's painting during the next several years. This was the beginning of his cubist investigations, setting the stage for later developments. Just before Weber's exhibition opened at the Haas Gallery, works by his innovative colleagues John Marin and Alfred Maurer were exhibited at Alfred Stieglitz's gallery 291, followed in May by an exhibition there of paintings by Marsden Hartley. These exhibitions marked the introduction of avant-garde tendencies in American art to the public.

21

By 1909 Alfred Stieglitz, America's eminent pictorial photographer, had begun to show paintings in his Little Galleries of the Photo-Secession, splitting his allegiance between artful photography and modern painting. Since the 1880s, Stieglitz had lobbied to have photography accepted as one of the fine arts, suitable for inclusion in art galleries and museums. In 1905, just as Weber headed across the Atlantic, Stieglitz opened his gallery at 291 Fifth Avenue—later known familiarly by the numbers of its address—as a showcase for the aesthetic endeavors of pictorial photographers. It also became the meeting place for a coterie of artists and intellectuals. In addition to operating 291, Stieglitz edited and published *Camera Work*, the most progressive art journal of the time. Begun in 1903 as a forum for pictorial photography, *Camera Work* eventually espoused ideas that so distanced it from its initial audience of amateur photographers that Stieglitz was forced to suspend publication in 1917 for lack of subscribers.

Weber's association with Stieglitz afforded him the opportunity to exchange ideas with the most progressive thinkers in America and to meet the artists and photographers who profoundly affected his artistic career.[4] Since his financial condition was precarious, he lived for several months in the shop of a decorator behind the gallery, and he frequently ate at the Holland House with Stieglitz and the 291 regulars.[5] In 1910 Temple Scott published an article in *Forum* magazine—a lightly disguised *histoire à clef*—in which he described Weber's role in the 291 circle. Weber appears as the central character, Michael Weaver (an English translation of Weber's German surname). Weaver is remonstrated with for his complaints about New York's inferiority to Paris, its loneliness and artistic sterility. The character Church—perhaps the critic Charles Caffin—entreats him to recognize the artistic advantages of America:

> Look at the Flatiron building! There it is stuck in the common rock. But, see, it mounts into heaven itself, a thing of beauty its sordid builders never dreamed of realizing. The sky has taken it unto itself as a part of its own pageantry. Let it be the symbol of your life.[6]

In the story, as in Weber's life, the artist is converted: "He looked up Fifth Avenue with far-seeing eyes and forgot the Boulevard Saint-Michel."[7]

In March of 1910 Stieglitz included Weber's paintings in the landmark exhibition *Younger American Painters* at 291, which featured the work of young innovative painters, many of whom had been in Paris and later became the leading American modernists: D. Putnam Brinley, Arthur B. Carles, Arthur Dove, Lawrence Fellows, Marsden Hartley, John Marin, Alfred Maurer, Eduard (later Edward) Steichen, and Max Weber. In the April 1910 edition of *Camera Work*, Stieglitz explained his rationale for exhibiting these radical painters:

> Photo-Secession stood first for a secession from the then accepted standards of photography and started out to prove that photography was entitled to an equal footing among the arts with the productions of painters whose attitude was photographic. Having proved conclusively that along certain lines, pre-eminently in portraiture, the camera had the advantage over the best trained eye and hand, the logical deduction was that the other arts could only prove themselves superior to photography by making their aim dependent on other qualities than accurate reproduction. The works shown at the Little Galleries in painting, drawing and other graphic arts have all been non-photographic in their attitude, and the Photo-Secession can be said now to stand for those artists who secede from the photographic attitude toward representation of form.[8]

This was the first major exhibition to survey modernist tendencies in America, and its revolutionary character baffled critics.

In the July issue of *Camera Work*, Stieglitz published a compilation of the critical responses to the *Younger American Painters* show.[9] Weber's work was the most frequently discussed. The reviews were mixed, and the critics were generally cautious in their comments, allowing for the possibility that the *Younger American Painters* represented the winds of change.[10] The comments of Elizabeth Luther Carey in the *New York Times* illustrate their general ambivalence:

> Max Weber's bits of still life are delightful, but his impressions of humanity, as in the grip of epileptic seizures, if taken seriously, as they must be, are eloquent of horror and nightmare.[11]

Weber was not in complete sympathy with the other exhibitors, as one of the reviews revealed:

> Hartley sees greatness in a weird picture of two figures by Max Weber, one of the recent recruits, which looks to the present writer like a very crude painting from an Assyrian tomb, but Weber can see nothing in Hartley's three waterfalls painted at different times of day, not even in a mountainside, which the writer is just beginning to understand.[12]

Weber's inclusion in *Younger American Painters* established him as a renegade artist with an unusually innovative vision. When Weber's work did not appear at the Independents exhibition organized by the realists in March of 1910, Arthur Hoeber wrote:

> They are independent enough but we miss the name of Max Weber, even more independent than any of the foregoing, and we wonder why he is left out of the group. Perhaps he would make the rest look conventional. We opine he would. At any rate no true Independent show would be complete without him, for alongside of him Mr. Davies appears almost old fashioned, while Mr. Luks today must be accounted no longer an insurgent, but a regular to whom we all take off our hats.[13]

Through his association with Stieglitz, the generator of the exhibition, Weber designed the installation for the 1910 *International Exhibition of Pictorial Photography* in Buffalo,[14] published articles in *Camera Work*,[15] and spent the summer of 1910 at Deal Beach (fig. 1) teaching Stieglitz's daughter Kitty to draw. Weber's close association with the Photo-Secession photographers, especially Stieglitz, Alvin Langdon Coburn, and

Clarence White, colored his artistic vision. His most challenging cubist paintings reflect insights related to their interaction and ideas. Weber's relationship with Alfred Stieglitz was tumultuous and brief, ending in 1911 after Weber's solo exhibition at 291.[16] The intellectual enrichment, however, was reciprocal. Stieglitz's eyes were opened by Weber's knowledge of art history, especially of European modernism, and Weber was introduced to Stieglitz's symbolic vision of the modern city as a concentration of engineering wonders and industrial machines, an emblem of America's eminence as a world power.

Weber's friendship with Coburn provided the most lasting and fertile interaction. From their initial meeting in 1910, they began a challenging and supportive association that influenced their artistic endeavors throughout the second decade of the century. After Coburn's return to England in 1912, they corresponded frequently, and their letters provide insight into Weber's artistic and intellectual activities during his cubist decade.[17] Thanks to Coburn's introduction of Weber's work to artist-critic Roger Fry, Weber was the only American to exhibit with the English Post-Impressionists, the Grafton Group, at the Alpine Gallery in London in 1913, and through Coburn's negotiations with the publisher Elkin Mathews in London and his financial support, Weber was able to publish a book entitled *Cubist Poems* in 1914.

Weber's disaffection with Matisse and the intense color of fauvism is evident in his article "Chinese Dolls and Modern Colorists," published in *Camera Work* in July of 1910 (p. 95). This scathing diatribe against the brilliant fauve style for which Weber himself had recently been criticized appeared in the same issue as his hallmark article "The Fourth Dimension from a Plastic Point of View," a discussion of painting in relation to the dialogue of science which details Weber's new formal and spiritual inclinations. Weber's attraction to the concept of the fourth dimension as "the consciousness of a great and overwhelming sense of space magnitude in all directions at one time, . . . brought into existence through the three known measurements" instigated his analytical approach to pictorial form in his cubist painting.[18] The significance of Weber's contributions to the scientific dialogue about the fourth dimension is thoroughly documented by Linda Henderson:

> The first connection between American art and "the fourth dimension," however, had occurred much earlier in the person of the American painter Max Weber. Weber had been in Paris in 1908, at the time the fourth dimension was first coming to the attention of French artists. Weber's article "The Fourth Dimension from a Plastic Point of View," printed in *Camera Work* in July 1910, was the first published discussion of the fourth dimension in art and was subsequently utilized by Guillaume Apollinaire in preparing his own explanation of the subject in *Les Peintres Cubistes* of 1911.[19]

Although Weber knew Picasso in Paris and had seen his paintings, cubist construction did not surface in Weber's work until his return to the United States.[20] Weber's earliest cubist explorations coincide with his introduction to the coterie at 291 and were probably inspired by the illustrations for the article "The Wild Men of Paris" by Gelett Burgess, published in *Architectural Record* in May 1910.[21] Illustrations of Picasso's *Three Women*, *Les Demoiselles d'Avignon* (fig. 2), and *Standing Female Nude* (fig. 3) and a drawing by Braque (reminiscent of Picasso's *Three Women*) in "The Wild Men of Paris"[22] bear notable affinities to Weber's incipient cubist figures, which he referred to as "crystal figures" or "form in the crystal." Picasso and Braque were not his only sources. Illustrations of works by Jean Metzinger, Othon Frieze, and the little-known Hungarian painter Béla Czóbel resemble a number of Weber's early cubist researches. In addition, Weber's interest in African art surfaced in his painting around the same time that Burgess illustrated Picasso's photograph with two African sculptures.[23] Weber's painting of his own African carving, *African Sculpture* [*Congo Statuette*] (cat. 1, p. 66) of 1910, documents his previous interest in African art. During the same year Weber incorporated an Aztec artifact in a still life, demonstrating his interest in other cultures and the breadth of his inspiration. Weber openly acknowledged his debt to "The Wild Men of Paris" in the painting of crystal figures he gave to Alvin Langdon Coburn, titled *Order Out of Chaos*, 1912 (cat. 28, p. 52), a paraphrase from Burgess's article. Burgess wrote:

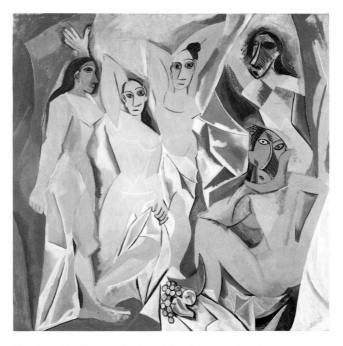

Fig. 2: Pablo Picasso, *Les Demoiselles d'Avignon*, 1907, oil on canvas, 96 x 92 inches, collection of The Museum of Modern Art, New York, acquired through the Lillie P. Bliss Bequest.

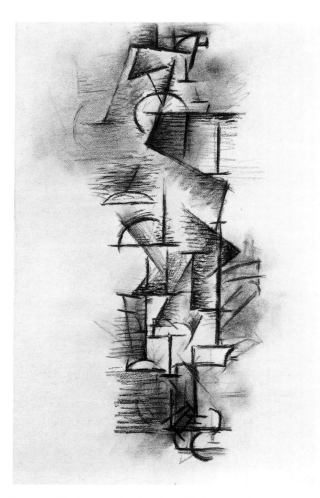

Fig. 3: Pablo Picasso, *Standing Female Nude*, 1910, charcoal on paper, 19 x 12⅜ inches, collection of The Metropolitan Museum of Art, New York, Alfred Stieglitz Collection, 1949. (49.70.34).

What magnificent chaps I met! All young, all virile, all enthusiastic, all with abundant personality, and all a little mad. But all courteous and cordial, too, patient with my slow-witted attempts to make order out of intellectual chaos.[24]

Weber's crystal figures, which date from 1910, reflect his interest in art, science, nature, and the spiritual. Mathematically perfect crystal structures fascinated scientists and were historically associated with the divine. Weber's aesthetic exploration of the human figure in crystalline terms aligned him with the intellectual dialogue of science, if not with its systematic rigor, and he proposed that crystal structure represented matter reduced to its lowest common denominator. His attraction to science is clear in "The Fourth Dimension from a Plastic Point of View." Like the French Cubists, Weber believed that a truer vision of reality could be found in a geometrical realm that served as the basic construction of matter. As he explained to his biographer Holger Cahill, "What is there particularly modern in Cubist painting? Its very logic, its plan is Euclidean."[25] Weber's crystal figures, however, tend to be dense structures in monochromatic shades of blue, unlike the transparent interpenetrating planes and beige tones of Picasso and Braque's analytical cubist paintings.

Weber's crystal figures are fundamentally studio nudes, revised and reintegrated to reflect contemporary scientific discourse on the nature of matter, and are similar to the cubist compositions illustrated in the Burgess article. When Weber exhibited his crystal figures in 1912, they received favorable reviews:

> The groups of figures of which there are many, all quite out of the reach of most of us, but there is a series of what Mr. Weber calls "crystal figures," suggested by the regular crystal formations, that are really remarkable, and in them he seems to have reached his highest mark.[26]

> His "Group of Crystal Figure Studies" are studies in which triads of color are employed with an exquisite appreciation of the dignified impression to be obtained by closely allied tints in combination. The nuances of "feeling tones" to use an expression of philosophy, are discriminated with a complete realization of their pleasure value, and the pattern made by the clearly defined sculptural edges of the various forms is calculated to produce the sensation which is given by the severe beauty of a hard material cut into decorative shapes.[27]

These innovative paintings are the earliest examples of cubist painting in American art.

The triple figures in some of these crystal studies, as in *Three Crystal Figures*, 1910 (cat. 6), relate to a passage from the Burgess article concerning the necessity of capturing all facets of a figure: "To portray every physical aspect of such a subject, he [Braque] said required three figures, much as the representation of a house requires a plan, an elevation, and a section."[28] Weber's adoption of this idea is reflected in *Women in Tents*, first titled *Woman and Tents*, 1913 (cat. 42, p. 54). Here,

the multiple bodies are intended to convey the essence of a single woman seen from different vantage points. The work was later exhibited as *Women and Tents*, obscuring his original intent. As in *Women on Rocks*, 1911 (cat. 17), Weber occasionally increased the number of views for an even more inclusive description. In 1910 an anonymous critic articulated Weber's early formal achievements and his similarities to Picasso:

> Max Weber, a young New York painter, is one of the men who is seeking to make plastic, visible on canvas this unseen essential constitution of matter. He resembles in a part of his work the French artist Picasso, who has analyzed matter into cubes and triangles which he reproduces on his canvas. Weber and Picasso may be wrong in the forms they hit upon as the principles of matter: it is the attempt that is significant. They point out that the microscope shows unseen forms which are essential, fundamental, and therefore beautiful. They have faith that the principles of existence, rendered plastic, are lovely.[29]

In the October 1911 issue of *Camera Work*, Stieglitz compiled the criticism for the Weber exhibition as he had done for the *Younger American Painters* exhibition the previous year. Arthur Hoeber of the *New York Globe*, who had been so responsive to Weber's experimental work in 1910, was by 1911 a vehement critic:

> The more the work is strange, crude, awkward, appalling, evidently the more it is in favor with him. The present display marks the high-water mark of eccentricity. If it has any reason to exist, then the eyes of the world in general are wrong, which, by the way, is just what these men insist. . . . Here are travesties of the human form, here are forms that have no justification in nature, but that seem all the world like the emanations of someone not in his right mind, such as one might expect from the inmate of a lunatic asylum, and the landscapes have an equal relation to nature as the world generally sees it.[30]

The majority of the critics reacted with equal venom in 1911. Elizabeth Luther Carey's response in the *New York Times* was more balanced:

> Mr. Weber, together with the rest of the Post-Impressionists, rejects the idea of representation as a true function of art, and those who are inclined to see in his distorted forms and faces, contradicting all our preconceived ideas of the normal human countenance, only the incoherent expression of the painter untrained in the grammar of his language, will do well to prepare themselves by a glance at the charcoal drawing in the smaller room, an "academy" drawn according to the usual conventions of the life class, but of extraordinary, of truly surpassing merit. Obviously it is the choice of knowledge, not the accident of ignorance, that has tempted the artist into these new paths.[31]

Critical reception to Weber's exhibition at the Murray Hill Galleries the following February was divided between the progressive and traditional camps. The progressive critics realized the implications of "Weber's Weird Work,"[32] while the conservatives refused to consider it viable artistic expression. Regardless, Weber was mentioned frequently in the press and had begun to establish his reputation as an important—if controversial—artist.

By 1912 Weber was interchangeably referred to as a cubist, a futurist, and a post-impressionist, with little distinction. In 1912, however, an article in the *Newark Evening News* attempted to explain Weber's "New Art of the Futurists":

> Perhaps neither he [Weber] nor any one of the men whose pictures are now shown at the Powell Galleries would call themselves futurists. Some of them in large measure and perhaps all of them in some measure partake of the expressed doctrines of that school, however. These are: The determination to break from every form of imitation, to be unhampered by "harmony" and "good taste" as fixed by canons; to express "the whirlwind of life." They aver that motion and light destroy the concrete aspects of objects. To find a new technique which shall enable them to present this reality of motion and light is a part of their dream.[33]

Although Weber may have been sympathetic to these aims, he was ambivalent about being linked with European modernist movements. His 1914 book of poetry was called *Cubist Poems*, but he became increasingly hostile to being so labeled. In the sequel to Temple Scott's article on the Stieglitz group, "The Faubourg Saint Bron-nex," of 1912, the exasperated Michael Weaver complains about the designation Post-Impressionism.[34] In 1916, Weber wrote:

> Isn't any ism an isolation and momentary
>     and not a universality?
> My dear Leonard
> I'm not an *ismist*!
> I claim to be no more
> than an integral
> part of the universe
> but that's enough to be
> isn't it?[35]

In spite of his attempts to distinguish his faceted figures, Weber was frequently relegated to the position of follower of French modernism.[36] After the *International Exhibition of Modern Art* in New York's 69th Regiment Armory, from February 17 to March 15, 1913, highlighted the spectacular achievements of the European avant-garde, Weber and other American moderns lived under the shadow of European artists. Throughout the second decade of the century they struggled to distinguish their artistic achievements.

# PERFORMANCE

**W**eber's return to the United States had marked the end of his apprenticeship and his embarcation on the mature phase of his career. He quickly extended his range of subjects to include café scenes, athletic events, cinema, theatrical productions, and music. Many of his major works from these critical years of his career examine the cultural and social life of New York, especially performance. For Weber performance—theatrical, musical, cinematic, athletic, or terpsichorean—was a metaphor for the making of a work of art. In painting, the time-consuming process of artistic creation is obscured by the unchanging image of a single isolated incident, whereas in performance it is an obvious component of the artistic event.

Popularized in the late nineteenth century by Parisian artists, genre paintings of cafés, theatres, and athletic events became emblematic of modern life. Weber's first cabaret and vaudeville paintings of 1909 are scenes of contemporary events similar in construction to the illustration of Czóbel's *Moulin de la Galette* in "The Wild Men of Paris."[37] Weber, however, became increasingly interested in patterns of movement as a distinctive characteristic of his era. After 1911 his figures revealed his interest in prismatic fragmentation. These works are more sophisticated in structure than his early crystal figures; in them, dynamic movement is suggested by overlapping planes and thrusting lines of force.

Weber's first vaudeville pictures of 1909, with lingering fauve characteristics of bright colors and textured paint, depict dancers whose disjointed anatomy appears to have been photographed in sequence and then printed in overlapping negatives. The short frilly costumes of the dancers are evidence of their extrapolation from the popular stage entertainments at Coney Island. In a series of pastels of dancers of 1912 (cat. 20, p. 52), however, the dancing figures have simple loose-fitting costumes and unusual poses imitative of the innovative forms of modern dance introduced by Isadora Duncan.

A revolutionary dancer of international acclaim, Duncan had presented two concerts in New York by 1912 that Weber could have seen.[38] In Duncan's early concerts, she danced alone on a bare stage in simple, loose-fitting attire. The short dark hair surrounding the face of Weber's dancer is similar to the style that Duncan wore. Repeated figures in Weber's pictures are probably intended to designate a solo dancer in sequential movements, emulating the freedom from classical structure advocated by Isadora Duncan (fig. 4). Weber's friend Walkowitz was enchanted with Duncan and he repeatedly depicted her in a variety of lyric poses. Unlike Walkowitz, Weber was more interested in the pattern of the dance than in the mystique of the dancer.

Weber's most exciting dance painting, *Russian Ballet*, 1916 (cat. 60, p. 63), is based on his memory of the theatrical production he attended with Arthur B. Davies.[39] With its

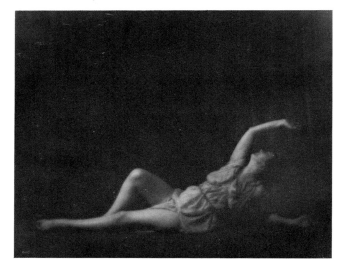

Fig. 4: Arnold Genthe, *Isadora Duncan*, ca. 1916, gelatin-silver print, 10¹¹/₁₆ x 13⅞ inches, collection of the National Portrait Gallery, Smithsonian Institution, Washington, D.C.

richly colored stage and triangular spotlights on the spinning motion of the central dancer, *Russian Ballet* is an homage to his homeland as well as to the cultural richness of New York. Weber's interest in the subject may have been encouraged by Coburn, who wrote him in June of 1914:

> I went to the Russian Ballet the other night and saw three—Daphnis and Chloe by Ravel, Papillons by Schumann, and Petrouchka by Stravinsky. It was all very wonderful. Stravinsky's music is very modern and interesting. Have you heard any of it?[40]

In his dance paintings, Weber addressed art and its production as a subject, as well as issues of space and time. In choosing to translate the fluid patterns of the dance into the static two-dimensional form of painting, Weber attempted to represent the spirit of experience rather than the moment of suspended action as had earlier painters such as Edgar Degas. Dance serves as an appropriate metaphor for Weber's painting, for the finished product has an ease and a grace that belies the struggle and the time of its construction. In visual art the work itself is the result of the process of its creation, whereas dance is more ephemeral and its residue is merely the memory of its passage. Weber sought to synthesize the multiple stages of performance and record a lasting memory of it.

The catalyst for Weber's increasing use of movement patterns may have been a series of articles on Futurist painting that appeared in New York newspapers in 1911 and 1912.[41] The Italian Futurist Gino Severini popularized images of dancing figures in Parisian cafés, and his painting *A Dancer* was illustrated in *The New York Herald* on December 24, 1911.[42] Although Weber's initial formal experiments derived from cubism, he was increasingly concerned with dynamic motion, the concept most characteristic of Italian Futurist painting. In 1913, Marcel Duchamp's *Nude Descending a Staircase, No. 2*, 1912 (fig. 5) was a scandalous success at the Armory Show. A drawing by Weber from the same year, referred to by the same title (cat. 33, p. 71) acknowledges his familiarity with Duchamp's painting, yet his figure is more closely related to his own stationary *Bather*, 1913 (cat. 34, p. 55) than to Duchamp's radically dynamic nude. Nevertheless, Duchamp's infamous painting, with its implication of sequential movement, was a touchstone for Weber.

Weber's original titles often signify his concern for the fleeting nature of existence and his attempts to grasp the poetic spirit of it. *Chinese Restaurant*, originally called *Memory of a Chinese Restaurant*, 1915 (cat. 51, cover), and an unlocated painting exhibited as *A Comprehension of the International Exhibition at the Armory* were meant to reflect the spirit rather than the photographic character of the place. Like his Parisian counterparts, Weber struggled to convey the ephemerality of sensations and the relation of time to art (the title of an article on photography by Coburn, published in *Camera Work*).[43]

Weber shared a passion for music with Coburn and discussions of music recur in their correspondence.[44] Weber's love of music seriously rivaled that of art and challenged his choice of

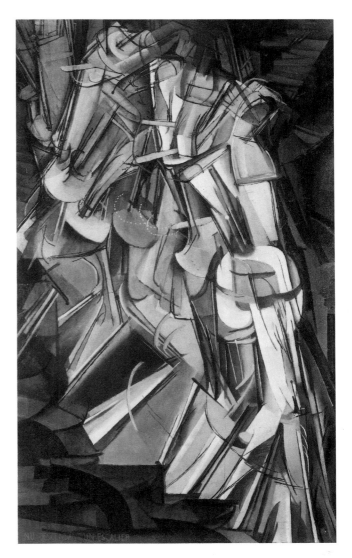

Fig. 5: Marcel Duchamp, *Nude Descending a Staircase, No. 2*, 1912, oil on canvas, 58 x 35 inches, collection of the Philadelphia Museum of Art, Louise and Walter Arensberg Collection.

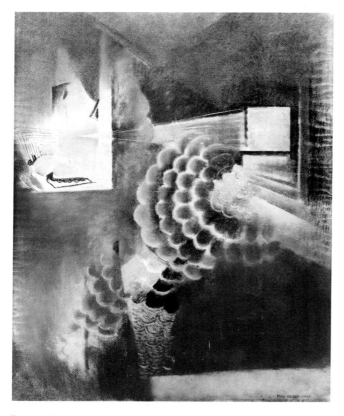

Fig. 6: Max Weber, *Lecture at the Metropolitan Museum* [*Lecture Phantasy*], 1916, pastel on paper, 24½ x 18¾ inches, collection of The Metropolitan Museum of Art, New York, gift of Dr. Irving F. Burton, 1975. (75.321).

career. Since childhood he had sung in choirs and played the cello; he later took voice lessons in Paris. Weber sought to capture the experience of sound through space and color and to establish correspondences between the senses. Not surprisingly, musical themes are prevalent in some of the most spectacular and intellectually challenging of Weber's cubist works. In a discussion of *Interior With Music*, 1915, for his retrospective at the Museum of Modern Art in 1930, Weber explained:

> There are moments when our senses seem to take on the functions of each other. To hear is to see, to see is to touch, and so it seems that the audible tones of music float and interlace or blur in space as do volumes of smoke or even vapors or aromas. Here is an expression of a conception of music as it wafts in space and is encased or seized in rhythmic architectural contour. The visible gamut of color seemed appropriate at the time for the harmony of music then heard in silence and isolation.[45]

Weber's interest in the correspondences between disparate artistic media surfaced in his depictions of dancers and musicians. His musical subjects are of two distinct types: descriptions of the activity of musicians in performance (similar to the repeated patterns of the dancers) and replications of the space-filling aural sensations of sound.[46] In 1911 Weber wrote to his friend from the 291 circle, van Noppen:

> I am thinking, and in fact I am writing, but in a very condensed way—upon the abstract in art—through the most real means—I find that music, which I used for comparison with plastic art, which is more abstract —our art is even more abstract for the means of realization are more material.[47]

Weber's early years in New York coincided with the proliferation of moving pictures, which were then challenging the popularity of live stage amusements.[48] Weber was quick to grasp the implications of the cinema as a rival to both the visual arts and theatre. Cinematic subjects began to appear in Weber's work as early as 1913, the year that narrative moving pictures were first produced in play-length form emulating theatrical productions.[49] Directors such as D. W. Griffith used the powerful illusion of film to replicate historical tales and locations, many of which were based on earlier theatrical productions. Weber's debts to contemporary cinema are revealed in two of his poems of 1914, "Silhouette" and "I Wonder." In "Silhouette" he describes the experience of being in a dark theatre facing the screen. "I Wonder," in which he muses about an imaginary relationship with an unknown woman in the cinema theatre, begins with a description of a newsreel that he had seen:

> Many men, many women,
> Young and old people.
> I sat with them gazing
> With them I laughed at the picture story
> Now the St. Mark's in Venice, and gondolas,
> Now scenes of industry in Arabia
> A picture story ended.[50]

In the pastel *The Screen*, 1913 (cat. 39, p. 70), Weber treated the paper medium as if it were a film screen, a tabula rasa on which images of the moving pictures could be eternally renewed, his metaphor for the artist's creative imagination. Here the screen is a red glowing rectangle floating in the dark space of the theatre. Thus the medium itself is the subject of artistic investigation. In his article "The Filling of Space," published the year he created *The Screen*, Weber explained the metaphor of the screen when describing the role of the photographer: "The photographer's art lies supremely in his choice or disposition of visible objects, as prompted and guided by his intellect and his taste. His mind is his screen."[51]

In the pastel *Lecture at the Metropolitan Museum*, 1916 (fig. 6), Weber assessed the relationship of the screen and of mechanical equipment to intellectual and sensory delectation. The pastel also had autobiographical meaning for Weber, who lectured on art history for the Clarence H. White School of Photography, using slides from the Metropolitan Museum of Art.[52] The projected triangular beam of light emanating from the projector is the motif of the picture, rather than the lantern slides or the lecturer. For Weber, the possibilities of electricity and incandescent lighting appear more exciting and dramatic than the art being discussed. Paradoxically, *Lecture at the Metropolitan Museum* celebrates technology at the expense of visual art, yet the brilliant color of the pastel demonstrates the futility of looking at works of art in the form of black-and-white lantern slides. Weber conceived of painting as a spiritually elevating experience, and the role of the artist was to reveal a higher level of consciousness than could be derived through photography and motion pictures, even though technology represented the spirit of the century.

Two other paintings of 1913 make oblique references to the experience of the cinema. Weber's reverie of his fantasy female from the cinema, revealed in his poem "I Wonder," resulted in his painting *Imaginary Portrait of a Woman* [*Imaginative Portrait of a Woman*], 1913 (cat. 35).[53] Although the subject does not appear to be placed in the theatre, the green curtain at the left side of the canvas suggests a stage-like setting. The portrait allowed the artist to bring his dream girl to life in the manner of the mythical Pygmalion.

Weber's painting *Women in Tents* [*Women and Tents*], 1913 (cat. 42, p. 54), at first seems to be an anomaly, for its seemingly Biblical subject is related to nineteenth-century romantic painting rather than to American modernism. Although *Women in Tents* appears at odds with Weber's consistent examination of themes of contemporary life in New York in major paintings from 1913 to 1915, a rationale for Weber's choice of the subject may be its derivation from D. W. Griffith's epic film *Judith of Bethulia* (fig. 7), the first four-reel Biblical costume drama, released in 1913. The film depicts the heroic action of the Hebrew queen Judith, who enchants the Assyrian tyrant Holofernes. In the climactic scene, she murders him in his tent to liberate her city of Bethulia, after first contemplating the deed alone in the tent. Like Griffith's more famous *Intolerance* of 1916, *Judith of Bethulia* was exhaustively researched and extravagantly detailed.[54]

In *Women in Tents* Weber adopted the exotic aura and period costumes of the film. The overlapping of identical female faces and arcing lines suggests billowing tent flaps and simulates the often jerky action of the film. The event Weber depicts is more exotic than horrific; he does not show the decapitation of Holofernes, but the time just prior to it when Judith is waiting in the tent for his arrival. In retrospect, Judith appears to be an ideal subject for Weber, whose later paintings of Jewish subjects were a popular success. This is the first of his major Biblical paintings and a subtle tribute to the advent of epic narrative cinema in America. Weber's cinematic subjects are exceptionally rare early examples of America's artistic consciousness of film and of its importance as a medium of mass communication.

In 1913, the year of the Armory Show, Weber began to work in a grander scale to create major impressive works, even though it was a struggle for him to afford paints and canvas. He reserved large canvases almost exclusively for paintings about the grandeur of New York and musical themes. His smaller works were still lifes, figures, and landscapes. During 1914 he worked most frequently in small scale, using watercolors, gouaches, and pastels on paper. His *Cubist Poems* of 1914 reflect Weber's painterly interests, although the language of the poems is archaic and the forms are not particularly progressive. Gertrude Stein's cubist writings were more adventurous, if less readable, than Weber's dreamy, evocatively personal poems. Weber began teaching art history and appreciation at Clarence H. White's newly opened School of Photography in 1914 and spent the summer with White and his family in Maine. During the summer he had malaria, which may account for the reduction of his production. In 1915, however, his creativity exploded in an extensive series of paintings exploring the vibrancy of New York.

Fig. 7: Still from D. W. Griffith's film *Judith of Bethulia*, 1913, courtesy The Museum of Modern Art/Film Stills Archives, New York.

# CITY OF AMBITION

Although New York at first seemed a cultural waste-land to Weber after the excitement and artistic fervor of Paris, he soon exploited the advantages of the burgeoning city. Weber initially intended to return to Paris, and he frequently spoke of his loneliness and longing for its creative atmosphere, as publicly acknowledged in Temple Scott's "Fifth Avenue and the Boulevard Saint-Michel." By 1920, however, he had changed his attitude:

> What do I want with in France? Its Gothic architecture is only a faded shaddow [sic] of Hindu architecture. Its hills or rivers. I'm not interested in French hills or rivers or cities or people. I'm interested in beauty, in nature, in man universal."[55]

Four years later, he stated: "Europe is nothing but a cemetery, and it will remain so for years. Hardly any art of living artists is sold."[56]

After Weber's departure for Europe in 1905, New York changed radically, and it continued to evolve rapidly from a sprawling American port into a modern industrial metropolis. By his return in 1909, what the city lacked in Old World charm of cafés, ateliers, exhibitions, galleries, and museums, it made up for in its rapid technological progress. In 1904, New York inaugurated a subway system, which, along with the electric trolleys and elevated trains, enabled riders to experience the city at accelerated speed. Since the 1890s, New York had been the most brightly illuminated urban center, and the proliferation of advertising signs along Broadway, the Great White Way, transformed the city into a fairyland at night.[57] In lower Manhattan, towers of commerce rose with increasing frequency and the low roofline of the nineteenth century was replaced by the canyons of the twentieth. In 1908 the Singer Tower was the tallest building in the world, with an observatory at the top for adventurous sightseers. Five years later, the Woolworth Building superseded it to reign, briefly, as the tallest building. The proliferation of subways, automobiles, department stores, moving pictures, increasingly brilliant illumination, and taller and taller buildings accelerated in Weber's absence so that the city demonstrated stark contrasts between the old world and the new when he returned.

In the spring of 1911, Alvin Langdon Coburn wrote to Max Weber from Los Angeles, "Don't forget that vision of New York from the harbour, that little sketch has whetted my appetite for what you will make of it."[58] Coburn's suggestion to Weber signals the first indication of Weber's attraction to the pictorial theme that had fascinated American photographers for almost two decades, from the time when Alfred Stieglitz turned his camera on New York's streets and buildings in search of iconic American images during the 1890s. Portraits of tall buildings, such as the popular Fuller Building or the Flatiron Building at 23rd and Broadway, recur in the works of Photo-Secessionists as emblems of urban technological prog-

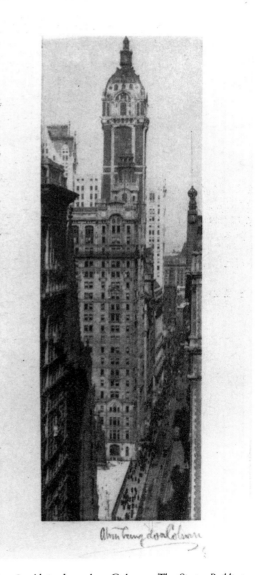

Fig. 8: Alvin Langdon Coburn, *The Singer Building, Noon*, 1909, platinum print, 4³⁄₈ x 17⁄₁₆ inches, collection Joy S. Weber. Inscribed "To Max Weber 1.15.10."

ress. As Merrill Schleier pointed out in *The Skyscraper in American Art, 1890-1931*, the modern city of tall buildings was specifically American, since the only tall buildings in Europe were churches that dotted the landscape.[59] Coburn's city photographs included a soaring portrait of the Singer Tower (fig. 8), a print of which he sent to Weber, and in 1910 he published *New York*, a book of his Manhattan photographs.[60] Coburn's early photographs of New York are soft-edged panoramas of the city taken from ground level, but during his association with Weber, he became interested in high vantage-point vistas. Like Stieglitz and other members of the Photo-Secession, Coburn abandoned the soft focus of pictorial photography for a crisper image of the city.

Painters were slower to find a compelling subject in the city. Pastoral idylls dominated late nineteenth-century American painting, and the radical artists of the first decade of the twentieth century were Ashcan School realists who depicted the activities of the inhabitants of the city. John Marin, the first of the 291 regulars to interpret the drama and dynamism of New York in paint in 1910, was joined the following year by Weber in his exploration of the formerly photographic theme. Marin's delicate watercolors of New York—the Woolworth Building was a favorite subject—are landmarks in American urban painting. However, like most of the 291 artists, Marin was more interested in nature than in the city. Weber remained the most urban of the early American modernists. For Weber, the city was a fusion of interior and exterior movement. His vision reflected an unphotographable vantage point on the city's dynamic surging energy, which directly influenced Walkowitz's later city paintings (fig. 9).

Weber's "little sketch of New York from the harbour," from 1911, inaugurated his major artistic investigation of the next five years, a time that was his most productive and adventurous. *New York*, 1912 (cat. 25, p. 69), one of a series of gouache and charcoal drawings that Weber produced that year, came into Coburn's possession and was to have been the frontispiece for Weber's book *Cubist Poems*, published through Coburn's efforts in 1914. Although the illustration was abandoned, the poem "The Eye Moment," which was to have been opposite the picture, remained as the introduction to the theme of the book. "Its opening 'Cubes, cubes, cubes' gives a deeper meaning to the title of the book," as Coburn wrote to Weber,[61] and is an indication of Weber's pictorial as well as poetic directions.

In 1911 Coburn published "The Relation of Time to Art" in *Camera Work*, in which he argued that photography was the medium best able to capture the soaring spirit of the city.

> Photography is the most modern of the arts, its development and practical usefulness extends back only into the memory of living men; in fact, it is more suited to the art requirements of this age of scientific achievement than any other. It is, however, only by comparing it with the older art of painting that we will get the full value of our argument plainly before us; and in so doing we shall find that the essential difference is not so

Fig. 9: Abraham Walkowitz, *Improvisation of New York City*, ca. 1916, oil on canvas, 43¾ x 33 inches, collection of Albright-Knox Art Gallery, Buffalo; George B. and Jenny R. Mathews, Elisabeth H. Gates, and Edmund Hayes Funds.

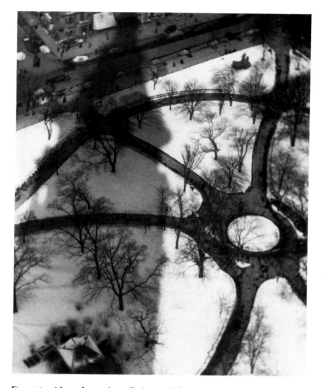

Fig. 10: Alvin Langdon Coburn, *The Octopus, New York*, 1912, platinum print, 16⁷/₈ x 12⁷/₈ inches, collection of the International Museum of Photography at George Eastman House, Rochester, New York.

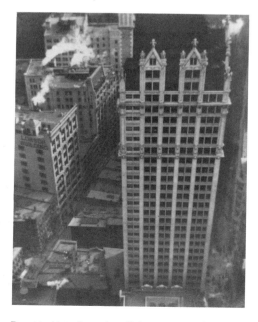

Fig. 11: Alvin Langdon Coburn, *House of a Thousand Windows*, 1912, platinum print, 9⁹/₁₆ x 7⁷/₁₆ inches, collection of Joy S. Weber.

much a mechanical one of brushes and pigments as compared with a lens and dry plates, but rather a mental one of a slow, gradual usual building up, as compared with the instantaneous, concentrated mental impulse, followed by a longer period of fruition. Photography born of this age of steel seems to have naturally adapted itself to the necessarily unusual requirements of an art that must live in skyscrapers, and it is because she has become so much at home in these gigantic structures that the Americans undoubtedly are the recognized leaders in the world movement of pictorial photography.[62]

During the first decades of the century, American painting reflected an aesthetic delicacy and sensibility based on traditional rules of beauty, grace, and elegance. The romanticism of this era's academic painting, including work by the Impressionists who called themselves "The Ten," was emulated by many of the pictorial photographers, especially Clarence White and Edward Steichen. Photographs of the city, such as Coburn's *Singer Building, Twilight*, 1908 (fig. 8), reflected the poetic nostalgia of romantic painting.

In 1913 Weber published a gentle rebuttal to Coburn's claim for photography as the art form most suitable to the century in "The Filling of Space" in the photographic journal *Platinum Print*. Weber characterized the differences between taking photographs and making paintings in favor of his medium:

> By reason of the lens being an indispensable instrument in the work of the artist-photographer, matter or nature, or scenes in nature are less yielding and flexible to his medium than to the living sensitive human eye, guided by and controlled with the mind, mood and time. The mind guides the hand, and all other senses are brought into play through spiritual contact and tactile intimacy with sound, light, motion, color, form; and the vision of phantasy after that.[63]

By the time Coburn's article was published in *Camera Work*, photographic depictions of the city were changing. Coburn, in particular, photographed the city from a strikingly high vantage point, looking down on skyscrapers, introducing a distinctly twentieth-century perspective on the landscape. His pictorial images became more stark and linear, and moved away from the soft focus of earlier pictorial photography. Coburn's romantic depiction of *The Singer Building, Twilight*, 1908, is an early attempt to memorialize the new cityscape. *The Octopus, New York*, 1912 (fig. 10), reveals a greater abstraction and the use of the city as a source for design elements. Coburn explained the curious title:

> The Octopus was taken from the top of the Metropolitan Tower, looking down on Madison Square where the paths form a pattern reminiscent of that marine creature. At the time this picture was considered quite mad, and even today it is sometimes greeted with the question 'What is it?' The answer is that it is a composition or exercise in filling a rectangular space with curves and masses, depending as it does more upon pattern than upon subject matter; this photograph was revolutionary in 1912.[64]

The shadow of the tower in the photograph is evidence of the location of the photographer. Later generations would think of this bird's-eye perspective as a view from an airplane, but this could only be anticipated in 1911, since passenger air travel was still a dream.

Coburn's vertical view of the city influenced Max Weber, whose several small watercolors of the park from 1912 are similar to *The Octopus, New York*. The synergistic nature of their relationship is evident in a comparison of Weber's *New York (The Liberty Tower from the Singer Building)* [*The Woolworth Building*] (cat. 27, p. 53) with Coburn's photograph *House of a Thousand Windows* (fig. 11), both made in 1912 of the Liberty Tower.[65] Both are similar in vantage point, but demonstrate the differences that Weber mentioned in his article in *Platinum Print*. Weber's painting reflects his increasing interest in cubism, which he embraced enthusiastically the following year. On his return to London after a visit to New York in 1912, Coburn wrote to Weber from his steamship:

> Tell me all the news about yourself, what new worlds are you conquering in your art and particularly how your New York creations are materializing. I will not forget our days together on the heights of New York.[66]

Coburn exhibited the results of their days on the heights at the Goupil Gallery in London in 1913 with the title "New York From Its Pinnacles," and Weber turned his attention to painting the vast scope of New York after this event.

Encouraged by Coburn, Weber painted a panorama of *New York* (cat. 25, p. 69) in 1912, contrasting the rising commercial towers of lower Manhattan with the structures of the old city and reducing the painting to a series of superimposed cubist grids.[67] This contrasting of old and new was not innovative for Coburn had made a similar juxtaposition in a 1908 photograph published in *Camera Work*.[68] Alfred Stieglitz similarly captured the spirit of the city's rapid transformation in *Old and New New York* (fig. 12) and *The City of Ambition* (fig. 13), both of 1910, published in his October 1911 edition of *Camera Work*.[69] Weber's prismatic interpretation of the city and emphasis on its geometric structure underscored the divergent possibilities of photography and painting. By 1913 Weber abandoned the elevated view of the skyscraper portraits for a more inclusive vantage point in order to convey the rhythms rather than the facade of the city, taking his cues from his earlier dance and cinema paintings. In Weber's major large-scale paintings, the viewer is in the midst of activity. Objects in Weber's paintings lose their identity and are integrated into the overall compositional design, thereby forming an unphotographable response to the visible world.

Weber's earliest depictions of the city, such as *Brooklyn Bridge*, 1911 (cat. 8), reflect the small scale and descriptive urban scenes of contemporary photography, such as J. F. Strauss's *Brooklyn Bridge* published in the third edition of *Camera Work* in July 1903. He became more confident of his work and its superiority to photography in 1913, inaugurating a series of large-scale paintings that captured the overwhelming scale

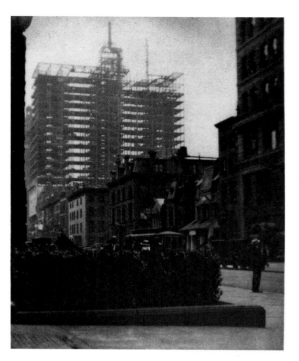

Fig. 12: Alfred Stieglitz, *Old and New New York*, 1910, callotype in *Camera Work*, no. 36 (October 1911), plate VI, 8 x 6¼ inches.

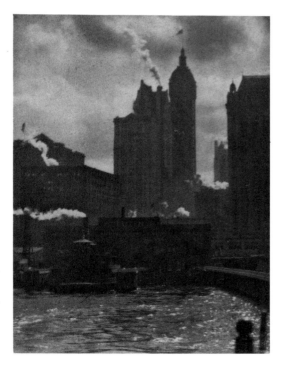

Fig. 13: Alfred Stieglitz, *The City of Ambition*, 1910, callotype in *Camera Work*, no. 36 (October 1911), plate I, 8¾ x 6⅝ inches.

and vibrancy of New York, and adopting the stylistic dynamic "lines of force" used by the Italian Futurists to simulate surging movement. Although Weber shared the subjects and formal vocabulary of the Futurists, his work is more expressive and less politically charged. By 1913, the year of the momentous Armory Show, Weber had arrived as a master, drawing from both cubism and futurism. In paintings titled *Interior of the Fourth Dimension*, 1913 (cat. 37, p. 56), *New York*, 1913 (cat. 38, p. 57), *Women in Tents*, 1913 (cat. 42, p. 54), and *Tapestry #1*, 1913 (cat. 41, p. 73), he began to compile a visual dictionary of the city's best cultural offerings.

Weber's most unusual and intellectually challenging painting of 1913, *Interior of the Fourth Dimension*,[70] exemplifies ideas espoused in "The Fourth Dimension From a Plastic Point of View" in *Camera Work*:

> In plastic art, I believe, there is a fourth dimension which may be described as the consciousness of a great and overwhelming sense of space-magnitude in all directions at one time, and is brought into existence through the three known measurements. It is not a physical entity or a mathematical hypothesis, not an optical illusion. It is real, and can be perceived and felt. It exists outside and in the presence of objects, and is the space that envelops a tree, a tower, a mountain, or any solid, or the intervals between objects, or volumes of matter if receptively beheld. It is somewhat similar to color and depth in musical sounds. It arouses imagination and stirs emotion. It is the immensity of all things. It is the ideal measurement, and is therefore as great as the ideal, perceptive or imaginative faculties of the creator, architect, sculptor, or painter.[71]

In *Interior of the Fourth Dimension* Weber continued his examination of the city; a boat appears in the foreground with tall buildings surrounding it in a stage-like setting that dramatically drops off into darkness at the sides. The negative space that frames the central overlapping shapes and the flickering light simulate the sensation of watching cinema. The painting portrays a glowing scene of New York from the harbor, and it is Weber's ultimate response to Coburn's 1911 entreaty.[72] In contrast, Weber's friend Samuel Halpert also painted a large canvas of the city from the harbor, depicting a two-masted ship sailing under the Brooklyn Bridge in 1913 (fig. 14), but in a much more traditional manner.

Weber became fascinated by the city at night, like Stieglitz, who had initiated night photographs of the city with his 1893 images of the Ritz Hotel. For Stieglitz, night photography demonstrated his mastery of difficult technical problems. Weber's paintings of the city at night demonstrate his mastery of a complicated formal vocabulary to express his emotional response to the urban experience. In 1915 he investigated the spatially deceptive properties of darkness in the magical city at night in two large oil paintings, *Night*, 1915 (cat. 56, p. 60) and *New York at Night*, 1915 (cat. 54, p. 60). David Nye, in *Electrifying America: Social Meanings of a New Technology*, explained:

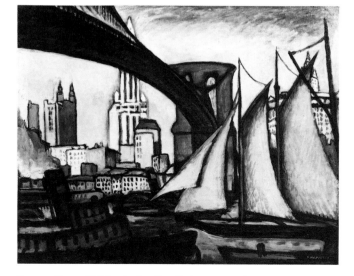

Fig. 14: Samuel Halpert, *Brooklyn Bridge*, 1913, oil on canvas, 34 x 42 inches, collection of the Whitney Museum of American Art, New York, gift of Mr. and Mrs. Benjamin Halpert.

Dramatic lighting transformed the gloomy night city into a scintillating, sublime landscape, and presented a startling contrast to the world seen by daylight. The development of White Ways and illuminated buildings, the triumph of electrical advertising, and the visual simplification of the city into a glamorous pattern of light together signalled more than the triumph of a new technology. Spectacular lighting had become a sophisticated cultural apparatus. The corporations and public officials who used it could commemorate history, encourage civic pride, simulate natural effects, sell products, highlight public monuments, and edit both natural and urban landscapes.[73]

Weber described his *New York at Night:*

Electrically illumined contours of buildings rising height upon height against the blackness of sky now diffused, now interknotted, now pierced by occasional shafts of colored light. Altogether—a web of colored geometric shapes, characteristic only of the Grand Canyons of New York at Night—.[74]

The most significant event for modern art in America, the *International Exhibition of Modern Art*—known as the Armory Show—organized by the Association of American Painters and Sculptors under the direction of Arthur B. Davies, included over one thousand catalogued works. Designed as a carefully selected survey of European and American modern art, the Armory Show was also an independent exhibition: American artists could exhibit two paintings by paying a fee. It was the first large-scale introduction of modern art to a broad American audience and it generated wide-spread controversy.

Although Weber's friend Davies was the head of the Armory Show committee, Weber was not invited to exhibit any more than the two paintings allowed in the open section. Weber was so offended that his innovative works were not further appreciated by the committee that he refused to participate in the exhibition. Weber's haughty behavior was not merely the response to a personal rebuff. In a review of his exhibition at the Murray Hill Galleries in February 1912, a critic proclaimed him "probably the most important of the painters who in this country are steadily working toward the new expression of aesthetic consciousness tagged 'Post-Impressionism.'"[75] With the refusal of the Italian Futurists to exhibit, the Armory Show was weakest in this dynamic facet of modernism. At that time, only Joseph Stella's *Battle of Lights, Coney Island,* 1913 (fig. 15) could rival Weber's futuristic paintings in America.

Fortunately for Weber, Coburn was promoting his work in England with Roger Fry, who included Weber's work in his exhibition of the Grafton Group (England's most eminent Post-Impressionists) at the Alpine Gallery, the month before the Armory Show. During the summer of 1913 Weber was invited by director John Cotton Dana to have a solo show at the Newark Museum. This was the first museum exhibition for a modernist American painter and placed Weber at the forefront of his colleagues. At this early date he received official recognition from the art world, even if he continued to be

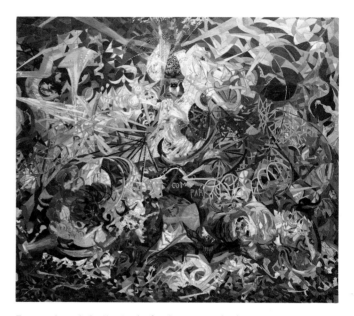

Fig. 15: Joseph Stella, *Battle of Lights, Coney Island,* 1913, oil on canvas, 76 x 84 inches, collection of the Yale University Art Gallery, gift of Collection Société Anonyme.

attacked in the popular press.

In his first large-scale picture of *New York* (cat. 38, p. 57), painted in 1913 and exhibited that year in London, Weber depicted the city as an architectonic maze of tall buildings interlaced with the snaking forms of elevated trains.[76] *New York* was the painting most frequently referred to by name by the English critics. This was due in part to the fact that the English artists hung their works without titles or signatures, while only the foreigners, Wassily Kandinsky and Max Weber, signed their paintings. Weber's *New York* would have been one of the few identifiable paintings in the show. The London critics' response to *New York* was similar to the antagonistic reviews Weber received earlier in New York:

> But Herr Kandinsky is not the only "eccentric"; he is almost beaten by Mr. Max Weber, who exhibits a picture of New York. In this we recognized nothing but two huge and twisted pythons and a series of organ keyboards; the rest of the canvas was occupied with big slabs of colour of a most grotesque shape.[77]

> Most puzzling is "New York," the work of Mr. Max Weber of that city, whose studies have not before been seen in England. Even after a prolonged examination, it resembles nothing so much as a concertina, that, inextricably mixed up in some fashion with the Stars and Stripes, has met with a violent end, and had stakes driven through it afterward. A faint serpent of smoke plays hide and seek in the whole conglomeration.[78]

A clever editorial by a Mr. Alfred Thornton of Bath was published in the *Observer* after the close of the show:

> At bottom, I fear, much of this is the cry of vested interest: the older conventions fancy themselves threatened and certain comfortable incomes imperilled. After all, there is room for all types of artistic expression, and the newest may be based on a far surer foundation than has hitherto been suspected. For instance, the decorative presentation of New York by Mr. Max Weber shown at the Grafton Group Exhibition just closed is a very fair representation of the kind of mind picture that frequently floats before me at the delightful daily phase of existence that lies between sleeping and waking—the state called "hypnagogic" by psychologists—a perfectly normal condition, quite as much worth reproducing as transient effects of landscape.[79]

In addition to orchestrating Weber's inclusion in the Grafton Group exhibition and the publication of *Cubist Poems*, Alvin Langdon Coburn encouraged Weber to explore certain pictorial subjects. In a letter of April 6, 1915, Coburn suggested to Weber that he make a painting commemorating their congenial visits to New York's Chinatown:

> You speak of China-Town. How fine it would be to foregather and have fine steaming "noodles" together, all the friendly bunch of us. Has it ever occurred to you to make a "Memory Picture of the essence of China-Town?" It seems to me that this would be a splendid thing to do. There is something quaintly romantic in the sounds and smells of it, its shops and pots and chop

Fig. 16: Anonymous, *Portrait of Max Weber in Chinese Costume*, ca. 1914-16, platinum print, 6⅝ x 4⅝ inches, collection of Joy S. Weber.

sticks of it, and I have a sort of intuition that you will do an exquisite blending of it all one day in honor of many nights (Happy ones) that we have spent there.[80]

Coburn's entreaty resulted in *Memory of a Chinese Restaurant* (later shortened to *Chinese Restaurant*) (cat. 51, cover), the most popular and frequently illustrated of Weber's cubist paintings. Like Coburn, Weber was a devotee of Chinatown, and he was even photographed in oriental costume (fig. 16). Weber explained the disorienting nature of *Chinese Restaurant* as a response to entering the lively, brightly illuminated room from the darkness of the night outside.[81] The splintered forms and explosion of patterns simulate his immediate sensory experience. By comparison, Ashcan realist John Sloan depicted the same subject in 1910 (fig. 17), highlighting a diner in the rich red of the restaurant, whereas Weber expressed his response as an active multi-sensory experience.

*Chinese Restaurant* is unusual among Weber's cubist city pictures in that it includes fragmentary slices of human anatomy to suggest the activity of the oriental waiters. As in the urban views by the Photo-Secessionist photographers, the gargantuan scale of the city precluded the visibility of human beings. Since *Chinese Restaurant* represents a modestly scaled interior space, its intimacy allows for the presence of people in the painting. Although Weber's other major cubist paintings from 1913 to 1915 featuring figures—*Tapestry #1*, 1913 (cat. 41, p. 73), *Women in Tents* (cat. 42, p. 54), and *Athletic Contest*, 1915 (cat. 49, p. 63)—focus attention on human activity, the majority of his city pictures represent the city as a gigantic machine.

Dominic Ricciotti has examined Weber's investigation of urban transportation in New York and his use of a futurist mechanistic vocabulary to define the city's modern dynamism in *New York*, 1913 (cat. 38, p. 57), *Rush Hour, New York*, 1915 (cat. 57, p. 62), and *Grand Central Terminal*, 1915 (fig. 18). For Ricciotti, Weber's *Rush Hour, New York*

> is a paradigm of locomotion; in choosing the twice daily rush through the city, the artist dramatized those peak periods when the urban machine churned most forcefully. *Rush Hour* embodied the Futurist principle of 'universal dynamism'—that the world is continually in a state of flux.[82]

Weber's investigation of perception based on the rapidity of modern transportation was preceded by Stieglitz's interest in urban transit, also a prevalent theme in the works of the Italian Futurists. The October 1911 issue of *Camera Work* featured Stieglitz's photographs of trains, boats, and planes, among them *In the New York Central Yards*, 1903 (fig. 19). For Stieglitz, vehicles were objects of beauty and fascination. Weber, however, was more concerned with the sensation of being in the machine and its effects on perception. His unlocated pastel *In an Automobile* documents a ride he took up Fifth Avenue.[83] For Weber, urban transportation signified the rapid pace and altered vision distinctive of the new century. His fragmented forms and dynamic lines of force simulate the experience of

Fig. 17: John Sloan, *Chinese Restaurant*, 1909, oil on canvas, 26 x 32¼ inches, collection of the Memorial Art Gallery of the University of Rochester, Marion Stratton Gould Fund.

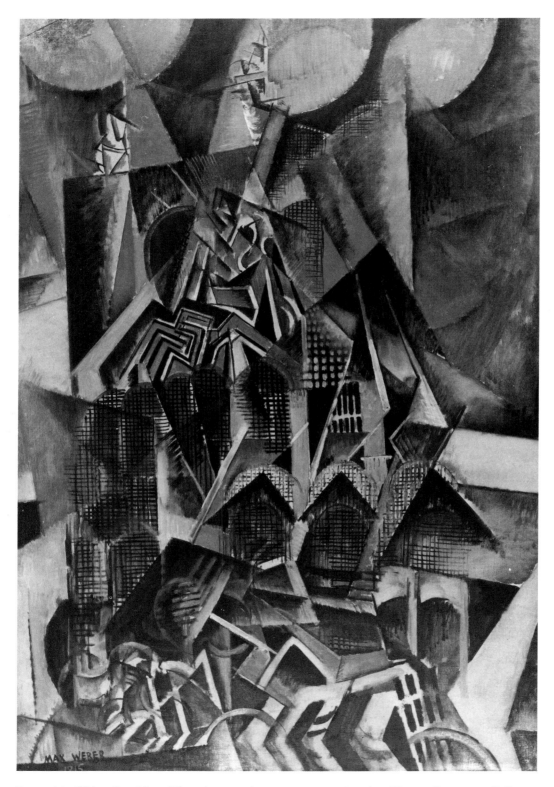

Fig. 18: Max Weber, *Grand Central Terminal*, 1915, oil on canvas, 61 x 40⅝ inches, Thyssen-Bornemisza Collection, Lugano, Switzerland.

seeing tall buildings while rapidly moving past them. His paintings are intended to replicate the sensation of speeding through the cavernous city.

One of New York's great architectural marvels was Grand Central Terminal (fig. 20), completed in 1912. Designed to rival the monumental architecture of the past, the great vaulted spaces of the terminal evoked the cavernous spaces of the Roman baths. Weber ignored the classical implications of the massive architecture and concentrated on its function as a machine to move people. His painterly homage *Grand Central Terminal*, 1915, which reflects the airy openness of the building, is a record of the sensations of rushing through the spaces without stopping to savor the details.

The Brooklyn Bridge was the motif most frequently used by Weber to designate the locale of Manhattan. Since Weber had lived in Brooklyn as a child and had sailed under the bridge, it served as a link to his past. Weber's early watercolor *Brooklyn Bridge*, 1912 (cat. 18, p. 68), which had so intrigued Coburn that he acquired the work, was also admired by Roger Fry.[84] The Brooklyn Bridge was the subject of a small oil painting, a prose poem, and a lithograph from 1928; and it appears as well in *New York*, 1913 (cat. 38, p. 57), *New York Department Store*, 1915 (cat. 55, p. 61, originally titled *An Idea of a Modern Department Store*; it heralds the era of mass marketing at newly opened stores such as Macy's, fig. 21), and *The City*, 1918 (cat. 72, p. 84).

New York became the locus of the best of American culture, its conglomeration of sensations more vibrant and exciting than anything previously experienced. Weber's cubist paintings of the city are reminders of its magnificence. His remarkable series of paintings of Manhattan culminated in a lyrical pastel of 1918, *The City*, which featured, of course, the Brooklyn Bridge. The work, however, lacks the power and grandeur of his earlier city paintings and is elegiac in mood. After 1915, with the advent of the war, Weber abandoned his idealized vision of the mechanized city as well as his dream of returning to Europe. Weber's correspondence with Coburn and van Noppen (who was stationed in England as a lieutenant in the Navy) furnished him with European reports of the tragic conflict. Weber changed after 1915; his works became more intimate and personal. Human subjects and themes dominated Weber's work and reveal the transformation of his consciousness.

Fig. 19: Alfred Stieglitz, *In the New York Central Yards*, 1903, callotype in *Camera Work*, no. 36 (October 1911), plate XIV, 7⅝ x 6¼ inches.

## THE LAST ACT

t the end of 1915, in his review of Weber's third show of the year at the Montross Gallery in New York, the critic Henry McBride wrote, "Max Weber's cause, and the modern cause generally, is partly won, but not wholly. For that reason it is doubly interesting, because alive."[85] From here on, McBride was a consistent champion of Weber's work, and gave Weber the

Fig. 20: Anonymous, *Grand Central Terminal, View of 42nd Street and Vanderbilt Avenue Facades, New York,* ca. 1915, modern gelatin-silver print from vintage negative, 11 x 14 inches, courtesy of the New-York Historical Society.

support he needed to withstand the barrage of hostile criticism from conservative reviewers. Although academic critics continued to deride Weber's painting as strange and incomprehensible, a new refrain appeared in reviews of Weber's exhibitions during 1915. He was frequently chastised for what critics perceived as the imitative nature of his work, probably as a result of an exhibition of Picasso's paintings at the Modern Gallery. The title of a review of Weber's December show at the Montross Gallery, "Max Weber's Zeal in Imitation," reveals the tone of attack from writers now having some familiarity with European modernism.[86] Formal similarities in their paintings encouraged reviewers to criticize the accomplishments of the American after having seen the works of the French artist. The dynamic forms of Weber's large-scale paintings of 1913 to 1915 should have distinguished them from Picasso's cubist paintings, but numerous reviewers noted the similarities and chose Picasso over Weber, rather than acknowledging Weber's individuality.

Weber's work, however, increasingly received favorable reviews. As McBride claimed, the tide was turning in Weber's favor, and some critics began to acknowledge his leadership in American modernism. Reviews of Weber's exhibition in Baltimore in March 1915 were consistently positive: "The most exciting art event of the season in this peaceful, strictly conformist town, thus far, is the exhibition of Max Weber's work, on for a week at the Jones Galleries."[87]

Another writer offered advice on the way to approach Weber's work:

> It is always to be remembered that Mr. Weber is doing something quite unconventional. His ideals are other than those which inspire the painters of the moment, even the most advanced of them, and so it is that one must approach his work from quite a different point of departure. . . . From this you will perhaps understand that Mr. Weber's paintings are not in any sense replicas and counterfeits of the natural form of things seen, but rather a translation of spiritual essences, auric emanations, astral colors, vibrations and thoughts, a concrete expression, through exquisitely selected and blended tones, using pigments as the medium of expression.[88]

Another Baltimore newspaper, *The Evening News,* quoted Weber's explanation of his work: "My sole desire is to express myself: to paint what I see not with my eye, but with my consciousness."[89] In spite of the success of his three solo exhibitions in 1915—a record for an American modernist —Weber did not have another one-man exhibition until 1923. As he explained to van Noppen:

> I exhibit in collection exhibition here and in other cities, but no more wasting my energies on one man exhibitions and the beloved driven stupid public. That game isn't worth the candle. Although I'm glad I lit the candle when I was several years younger.[90]

Weber's exhibition at the Montross Gallery in December of 1915 included "30 small pieces of 'sculpture,' figurines and abstract forms for the most part colored."[91] His experimentation with planar shapes and cubist forms led to his exploration

Fig. 21: Anonymous, *Herald Square*, ca. 1903-04, modern gelatin-silver print from vintage negative, 11 x 14 inches, courtesy of the New-York Historical Society.

of abstract sculpture. He was among the earliest American artists to address abstraction rather than figurative issues in three dimensions. *Spiral Rhythm*, 1915 (cat. 58, p. 72), is the best known of his series of plaster studies, based on contrasts of air, light, and shadow. Some of the small-scale plaster works were later enlarged and cast in bronze, including *Spiral Rhythm*. The sculptures are revolutionary explorations, in America, of abstract planar forms.

In addition to finding a champion in the press, Weber also obtained his first consistent patronage in 1915. Mrs. Nathan J. Miller's fascination with Weber's *Interior of the Fourth Dimension*, 1913 (cat. 37, p. 56), and its acquisition by her husband as a surprise for her, began lifelong financial support for the artist. Mrs. Miller acquired a significant number of Weber's major early paintings, including *Women in Tents*, 1913 (cat. 42, p. 54), *Imaginary Portrait of a Woman*, 1913 (cat. 35), *Women in Trees*, 1911, and *Trees*, 1911 (cat. 16, p. 53). She assembled the most extensive private collection of Weber's painting, and also purchased work by other artists, including Cézanne and Weber's friends Samuel Halpert, Man Ray, and Marguerite Zorach.

While Weber's pictures were installed at the Print Gallery, the painter (later sculptor) William Zorach came to see the show. The meeting of these artists led to a close, supportive, and lifelong relationship. Weber was increasingly active in the socialist causes supported by Zorach. Weber and Zorach were two of the four organizers of the Call Bazaar in 1919 to raise money for the socialist journal *New York Call*. The same year, Weber's article "The New Humanity in Modern Art" was published in *New York Call*, describing his new direction in painting.[92] He explained:

> This essay emerges I might say from recent experiments with geometric form. My endeavor is to humanize geometry and have some unprecedented works to show you which are an outcome of my recent thinking and working in that vein.[93]

Weber's success of 1915 was followed in 1916 by the publication of *Essays on Art*, with the assistance of Clarence White, who helped promote the book. The twelve essays, transcribed from Weber's lectures at the Clarence H. White School of Photography by his future bride, Frances Abrams, addressed Weber's spiritual approach to artistic creation. As a 1917 brochure advertising Weber's art appreciation lectures explained: "The lectures are interpretive in character and greater emphasis is laid throughout the entire course upon the intrinsic plastic significance and intent of art, than upon historic and erudite data."[94]

Critical reaction to *Essays on Art* was not enthusiastic, if mixed. A writer for *The Nation* declared, "The style of the book is a very odd blend of the consciousness of Emerson with the cloudiness of Guillaume Apollinaire and the child's prattle of Gertrude Stein."[95]

The dominant theme of Weber's essays is the spiritual, but his writings are tempered by discussions of geometry, the fourth dimension, time, and chaos—subjects addressed in his paintings:

> Science dealing with facts and facts with use make possible endless physical or chemical combination. Material use is the great issue of science. Science experiments and its use or application is its proof. Science may advance as rapidly in the future as it has in the past. But physical science and metaphysics are not art, and cannot do for art.[96]

Weber's definition of art as "spiritual belief or truth" appears on the following page as a summation of his essay "Quality."[97] In a succeeding chapter, "Means," he sounded his persistent refrain: "The imagination or conception of an arrangement of forms or of a particular gamut of color in a green rectangle is not a matter of means but an inner spiritual vision."[98] Weber's attempt to capture the immateriality of spiritual ideals in material form generated his painting, poetry, sculpture, and prose. It led to his examination of the inner and outer spaces of solid forms that resulted in his fascination with cubist painting.

As Weber's life became increasingly stable, his paintings changed in form and content. After his marriage to Frances Abrams on June 27, 1916, he abruptly shifted the focus of his work away from unpopulated images of the architectonic city to portrayals of people. Weber glowingly described his honeymoon and its aftereffects to Leonard van Noppen: "It seemed to me the whole universe was sweetened."[99] Weber and his bride found an apartment in the Dyckman section of New York with a view of the Hudson, more bucolic than his former apartments in the center of the congested city.

Conversation pieces depicting families, friends, courting couples, and musicians became the subjects of his work: themes of human relationships dominated his painting for the rest of his career. As Weber's life changed, his work became more intimate, with haunting psychological overtones. His late cubist figures inhabit interior spaces that mirror the artist's introspection. During the early years of his marriage, domestic life took precedence over worldly concerns. He completely abandoned the active life of the city in 1921, when he purchased a house in suburban Long Island, where he lived for the rest of his life.

The figures in Weber's cubist paintings from 1917 to 1919 are rendered in a decorative style of cubism. Weber emphasized flattened space, the interaction of solid geometric blocks of bright color, and decorative textures and motifs. In these paintings, he abandoned the dynamic force lines and repeated shapes that had typified his major city paintings. His late decorative cubist paintings are similar to the post-collage synthetic cubist paintings of Picasso and Braque. Although Weber's later decorative works are similar to the forms of their synthetic cubist paintings, this phase of cubism was not widely known in America by the time that Weber adopted its motifs. An exhibition of Picasso's work held at the Modern Gallery in 1915 may have included examples of his new decorative style of cubism. Albert Gleizes, who exhibited at

291 in 1915, showed paintings of New York with some syn-
thetic cubist elements as well. Weber had met Gleizes and
they corresponded.[100] Weber may have been inspired by him
to adopt decorative cubist forms.

In 1918, Weber's leadership in the American art world was
recognized when he was selected a director of the Society of
Independent Artists. In a review of the Society of Indepen-
dents exhibition the previous year, the critic Henry McBride
had proclaimed, "Max Weber's *Women in Tents* [is] one of the
finest works of modern art yet produced by an American."[101]
Weber created his first series of graphic works based on the
cubist forms and subjects of his figure paintings in 1918. The
small woodblock prints, carved from honey boxes, show
Weber's exploration of graphic arts.

As Weber neared his fortieth birthday, his youthful ideal-
ism and radical experimentation declined. By 1920 Weber's
position as an important American artist was established, and
he retained his eminence, achieving popularity as well as
acclaim during the 1940s for religious paintings of Jewish
subjects. In 1937 he was proclaimed the "Dean of American
Moderns" in an article by the artist Jacob Kainen that was
frequently cited in Weber's obituaries.[102] The critical tide has
shifted, however, and the works for which Weber was
renowned during his life are out of favor. His reputation now
rests on his youthful cubist paintings.

During Weber's cubist decade, modernism came of age in
America, aided in part by Weber's avid and progressive exper-
imentation. His participation in 1919 on a jury to select works
for an exhibition of American art at the Musée du Luxembourg
in Paris indicated his importance as an American leader in
modern art. The exhibition signaled American painting's
arrival on the world stage. After World War I, however, the
stage changed for Weber, as it did for the majority of artists
who had explored modernist ideas before the war. Weber
returned almost exclusively to academic subjects—bathing
nude figures, landscapes, still lifes, and genre scenes, with
identifiable objects and traditionally defined spaces. His work
became lyrical and romantic albeit rough-hewn and expres-
sive. He painted familiar comforting pictures, not the star-
tling awkward figures of his cubist paintings. His work lost its
hard edge and its difficult stance. The end of Weber's cubist
decade coincided with the end of the first phase of modernist
experimentation in America.

PERCY NORTH

## NOTES

1. In 1910 the painter and critic Roger Fry organized *Manet and the Post-Impressionists* at the Alpine Gallery in London, featuring works by England's foremost modern painters, the Grafton Group. It was the first published use of the designation "Post-Impressionist."
2. Untitled review of Weber's Haas Gallery show, *New York Morning Sun*, April 30, 1909, Weber Papers, AAA (NY59-6), 390. Weber kept a clipping file, with dates on the articles inscribed in his hand, that is in the Weber estate and was microfilmed for the Archives of American Art [AAA]. Most of the articles appear without page numbers and they frequently do not contain the names of the writers.
3. "Weber at Haas Gallery," *American Art News* 7 (May 3, 1909): 6, Weber Papers, AAA (NY59-6), 390.
4. Alfred Stieglitz, *The Story of Weber*, a twenty-four page manuscript in the Stieglitz papers in the Beinecke Rare Book and Manuscript Library, Yale University. Sent to Edith Halpert on December 20, 1930, a version of the essay in the Archives of American Art is published in Percy North, "Turmoil at 291," *Archives of American Art Journal* 24, no. 1 (1984): 12-20. Stieglitz wrote that Weber came to 291 in 1909 at the suggestion of Eduard Steichen, whom he had known in Paris.
5. Ibid., 17.
6. Temple Scott, "Fifth Avenue and the Boulevard Saint-Michel," *Forum* 44 (July-December 1910), reprinted in *The Silver Age* (New York: Scott and Seltzer, 1919), 172.
7. Ibid.
8. Alfred Stieglitz, "Paintings by Young Americans," *Camera Work*, no. 30 (April 1910): 54.
9. "'The Younger American Painters' and the Press," *Camera Work*, no. 31 (July 1910): 43-49.
10. Israel White from the *Newark Evening News*, in "'The Younger American Painters' and the Press," *Camera Work*, no. 31 (July 1910): 45. "There's something doing in the world of art. The wind has been blowing, rustling the blinds, and still we slept. Now it rushes through the room and we must get up and see what's happening. Mr. Stieglitz will tell you that this is what it is; the men who have gone along with the tide have developed into makers of colored photographs. Then color photography—note the distinction between colored photographs and color photography—showed that the painters' colors were all wrong and that better results along this line could be secured mechanically. That knocks the pinning out from under the artistic house and the builder must set to work anew to secure more color and a new idea in painting."
11. Elizabeth L. Carey from the *New York Times*, in "'The Younger American Painters' and the Press," *Camera Work*, no. 31 (July 1910): 45.
12. P. B. Stephenson from the *New York Post*, in "'The Younger American Painter' and the Press," *Camera Work*, no. 31 (July 1910): 44.
13. Arthur Hoeber, "1910 Independents Show March-April," *New York Globe*, April 1910, Weber Papers, AAA (NY59-6), 385.
14. "The culmination of the photographic activity of the Photo-Secession occurred in 1910, the year of the famous Albright Exhibition in Buffalo, New York. The exhibition was intended to be the climax for the Secession activities, photographically, and a summation of all the activity which the Secession, in the person of Stieglitz, had carried on in the effort to establish

photography as a recognized art form. Two Secession members were in charge of the hanging under the direction of Max Weber, a painter and a friend of Clarence White. The exhibition opened November 4 and closed December 1. Contained in the exhibit were the most significant photographs of the entire membership of the Secession. . . . Weber recalled recently: 'I treated the geometric rectangles and features of the prints as windows in the walls of a building, and gave special attention to values of dark and light and tone to add to the decorative effect of the entire wall or entire gallery,'" Peter Curtis Bunnell, "The Significance of the Photography of Clarence Hudson White (1871-1925) in the Development of Expressive Photography" (Master's thesis, Ohio University, 1961), 52-53.

15. Max Weber, "Chinese Dolls and Modern Colorists," *Camera Work,* no. 31 (July 1910): 51. See p. 95 of this catalogue.

　　Max Weber, "The Fourth Dimension From a Plastic Point of View," *Camera Work,* no. 31 (July 1910 ): 25. See p. 95 of this catalogue.

　　Max Weber, "Xochipilli, Lord of Flowers," *Camera Work,* no. 33 (January 1911): 34.

16. North, "Turmoil at 291," 18-19. Reports by Weber and Stieglitz concur that they quarrelled over the prices of Weber's paintings.

17. The letters from Coburn to Weber are on file in the Archives of American Art, Weber Papers (N/69-85). The letters from Weber to Coburn are unlocated. Coburn's estate was dispersed to a number of sources, including the George Eastman House. Repeated queries have not revealed the letters. It seems unlikely, however, that Coburn destroyed them.

18. Weber, "The Fourth Dimension From a Plastic Point of View," 51. See p. 95 of this catalogue.

19. Linda Henderson, "Mabel Dodge, Gertrude Stein and Max Weber: A Four-Dimensional Trio," *Arts* 57 (September 1982): 107. Her book *The Fourth Dimension and Non-Euclidean Geometry in Modern Art* (Princeton: Princeton University Press, 1983) is an exhaustive study of the subject and Weber's role in it.

20. In *The Reminiscences of Max Weber,* interview by Carol S. Gruber (Oral History Research Office, Columbia University, 1958), 195, Weber claims that he met Picasso at Leo Stein's in Paris and that they became friends. There is a card from Picasso to Weber dated 1908, Weber Papers, AAA (NY59-7), 519.

21. Gelett Burgess, "The Wild Men of Paris," *Architectural Record* 27 (May 1910): 400-14.

22. Picasso's *Three Women* and *The Dryad* and the Braque drawing are entitled *La Femme; Les Demoiselles d'Avignon* is labeled *Study by Picasso.*

23. Weber was photographed with a small African carving he owned that served as the model for his gouache painting of 1910 referred to as *Congo Statuette* or *African Sculpture.*

24. Burgess, "The Wild Men of Paris," 404. In his unpublished essay "Plastic Expression," ca. 1912, Weber Papers, AAA (NY59-6), 132-33, he explains: "There isn't a sound, there isn't a color nor a form and certainly there isn't an image before it is born of matter. This reaction or expression is the dynamic. Each form of expression has its natural limitations. They may overlap but too much so makes for chaos."

25. Cahill, *Max Weber,* 11.

26. R. W. Macbeth, "Weber's Paintings on View in New York Product of 'Cubeist' [sic] School," *Christian Science Monitor,* February 26, 1912, Weber Papers, AAA (NY59-6), 392.

27. "More Post Impressionism," *New York Times,* February 18, 1912, Weber Papers, AAA (NY59-6), 358, repeated on frame 387.

28. Burgess, "The Wild Men of Paris," 405.

29. [Arthur Hoeber?], untitled article, *New York Globe*, October 24, 1910, Weber Papers, AAA (NY59-6), 385.

30. Arthur Hoeber, article from the *New York Globe*, reprinted in *Camera Work*, no. 36 (October 1911): 31.

31. Elizabeth Luther Carey, article from the *New York Times*, reprinted in *Camera Work*, no. 36 (October 1911): 34.

32. "Weber's Weird Work," *American Art News*, January 21, 1911, Weber Papers, AAA (NY59-6), 369.

33. "The New Art of the Futurists," *Newark Evening News*, March 2, 1912, Weber Papers, AAA (NY59-6), 386.

34. Temple Scott, "The Faubourg Saint Bron-nex," in *The Silver Age* (New York: Scott and Seltzer, 1919), 180. The story, written earlier, was published in this anthology.

35. Letter from Weber to Leonard van Noppen, May 18, 1916, Weber Papers, AAA (NY59-8), 135.

36. On October 27, 1914, Weber Papers, AAA (N69-83), 46-47, gallery owner Charles Daniel wrote to Weber in response to Weber's request for an exhibition: "My dear Mr. Weber—Thank you for your letter of October 24— In reference to an exhibition next year, would say that we hope to have an exhibition of original Matisses and Picassos, who will no doubt cover the modern field better than you can. Thanking you for your esteem. Sincerely, Charles Daniel."

37. Subsequently referred to as *Burlesque*, three paintings of 1909 were originally exhibited with the vaudeville title and depict events on the vaudeville stage rather than the ecdysiastical displays of the burlesque. The paintings reflect Weber's fauve style of painting, but the extremities of the dancing women do not represent conventional depictions of anatomy. The forms remain recognizable, but their placement is improbable. In *Reminiscences*, 255, Weber recalled that he went to Coney Island in the summer of 1909 to see burlesque dancers.

38. Isadora Duncan had solo dance performances at the Metropolitan Opera in November 1909 and at Carnegie Hall in February 1911. She usually danced in a loose-fitting garment either ankle length or falling to mid-thigh. She danced alone before 1917, after which she had a troop of young girls she referred to as the "Isadorables." She used a curtain in a pale solid color as a backdrop to silhouette her solitary figure, and she danced in her bare feet, a notable characteristic of the dancer in Weber's pastels of 1912. (Information on Isadora Duncan courtesy of Ruth Bohan.)

In a letter to Weber, May 8, 1911, Coburn mentioned the modern dancer Ruth St. Denis, Weber Papers, AAA (N69-85), 262.

39. Weber told Lloyd Goodrich, June 16, 1948, that he attended a production of the Russian Ballet in New York with Arthur B. Davies, Weber Papers, AAA (NY59-8), 267.

40. Letter from Coburn to Weber, June 14, 1914, Weber Papers, AAA (N69-85), 380.

41. John Oliver Hand, "Futurism in America: 1909-14," *Art Journal* 41 (Winter 1981): 337-42.

42. Ibid., 339. Weber did not share the anarchic political philosophy of the Italian futurists. Unlike them, he was severely distressed by the onset of World War I.

43. Alvin Langdon Coburn, "The Relation of Time to Art," *Camera Work*, no. 36 (October 1911): 72-73.

44. On January 22, 1914, Coburn wrote to Weber of his new gramophone and the records of Chinese music he had purchased, Weber Papers, AAA (N69-85), 342. During the 1910s, Coburn was so enamored of his mechanical pianola that he sacrificed his photography for the time-consuming task of cutting pianola rolls. In a letter to van Noppen, January 22, 1926, Weber mentioned that he was writing poems under the inspiration of Schubert's music, Weber Papers, AAA (NY59-8), 34-36 His musical tastes, therefore, may have been more traditional than Coburn's. In *Reminiscenses*, 166, Weber mentioned that he had been a choirboy.

45. Max Weber, annotation to the checklist, in *Max Weber*, introduction by Alfred H. Barr, Jr. (New York: The Museum of Modern Art, 1930), 17.

46. On July 8, 1914, Coburn wrote to Weber, "In return please give me a little note of your new 'music' pictures of which you wrote me. As I understand you they are the translations of your impressions of music into painting." Weber Papers, AAA (N69-85), 383.

47. Letter from Weber to van Noppen, May 3, 1911, Weber Papers, AAA (NY59-8), 87.

48. Linton Weeks, "Brave New Library," *Washington Post Magazine*, May 26, 1991, 11. In discussing the collection of the Library of Congress, Weeks commented on one of its holdings: "An eerie time-lapse demolition of Manhattan's Star Theater in 1902. The irony of the scene—the motion picture industry recording the death of a stage theater."

49. In 1913 the first epic feature-length moving picture, *Quo Vadis* by Enrico Guazzoni, was released in Italy, and D. W. Griffith released his first four-reel film, *Judith of Bethulia*, in the United States.

50. Max Weber, *Cubist Poems* (London: Elkin Mathews, 1914).

51. Max Weber, "The Filling of Space," *Platinum Print* 1 (December 1913): 6. See p. 97 of this catalogue.

52. *Reminiscences*, 276. In his annotations to the checklist of the Museum of Modern Art catalogue *Max Weber*, 18, Weber wrote about the picture: "A lecture on Giotto was given at the Museum. The late hastening visitor finds himself in an interior of plum colored darkness on leaving the glaring daylight, speed and noise behind. The darkness of the interior becomes a background on which one discerns the focussing spray-like yellowish white light, the concentric circular rows of seats, a portion of the screen, and indications of figures upon it. There was much more visible, but the memory retained only the essential expressed in this pastel study."

53. Exhibited in 1915 as *Imaginative Portrait of a Woman*, it has subsequently been referred to as *Imaginary Portrait of a Woman*. Letter from Coburn to Weber, February 8, 1913, Weber Papers, AAA (N69-85), 288. "Your fine long letter telling me of your new problem in painting has reached me, and I think the idea of painting the imagination of memory is most subtley interesting and I believe I have quite a definite idea of how you will work it out from your descriptions and what I know of your methods."

54. Bernard Hanson, "D. W. Griffith: Some Sources," *Art Bulletin* 54, no. 4 (Winter 1972): 493-515.

55. Letter from Weber to van Noppen, May 30, 1920, Weber Papers, AAA (NY59-8), 186.

56. Letter from Weber to van Noppen, June 14, 1926, Weber Papers, AAA (NY59-8), 214.

57. David Nye has recently examined the electrification of America and its far-reaching implications in *Electrifying America: Social Meanings of a New Technology* (Cambridge: MIT Press, 1990).

58. Letter from Coburn to Weber, March or April 1911, inscribed by Weber, Weber Papers, AAA (N/69-85), 259.

59. Merrill Schleier, *The Skyscraper in American Art, 1890-1931* (Ann Arbor: UMI Research Press, 1983).

60. Four of the photographs from *New York* were published in "Mr. Coburn's New York Photographs," with an excerpt from the introduction to the book by H. G. Wells, *The Craftsman* 19 (February 1911): 464-68. In addition to the print of *The Singer Building* signed "Alvin Langdon Coburn To Max Weber 15 XI 10," Weber Papers, AAA (N69-85), 260, prints of Coburn's *House of a Thousand Windows* and an aerial view of Trinity Church, along with Stieglitz's *Spring Showers* and a photograph of his daughter Kitty, are in the Weber estate. Unframed, the photographs were not valued as works of art.

61. Letter from Coburn to Weber, January 8, 1914, Weber Papers, AAA (N/69-85), 332.

62. Alvin Langdon Coburn, "The Relation of Time to Art," *Camera Work*, no. 36 (October 1911): 72.

63. Max Weber, "The Filling of Space," *Platinum Print* 1 (December 1913): 6. See p. 97 of this catalogue.

64. Helmut Gernsheim and Alison Gernsheim, eds., *Alvin Langdon Coburn: Photographer: An Autobiography* (London: Faber and Faber, 1966), 84.

65. The correct identification of Weber's *Woolworth Building* [*New York (The Liberty Tower from the Singer Building)*] (cat. 27, p. 53), as Henry Ives Cobb's Liberty Tower was made by Merrill Schleier, *The Skyscraper in American Art*, 59. Coburn simply may have liked the romantic title, *House of a Thousand Windows*.

66. Letter from Coburn to Weber, November 18, 1912, Weber Papers, AAA (N69-85), 270. Nine days earlier, on November 9, AAA (N69-85), 268, Coburn wrote to Weber from the ship: "It's a lovely morning and our New York looks splendidly in the shimmering morning light. This will come back to you by the pilot, my last message this side of the Atlantic—It will give me great pleasure in far away England to print the copies we made on that memorable day and send them to you."

67. A painting titled *Old and New New York* was exhibited in Weber's 1930 retrospective at the Museum of Modern Art. The work may have been *New York*, 1912. The title reiterates the connections between Weber's painting and Stieglitz's photography.

68. Alvin Langdon Coburn's photograph *New York*, published in *Camera Work*, no. 21 (January 1908): 37, among a group of twelve views by Coburn in the issue, is a view from the harbor with the masts of ships silhouetted against the low roofs of buildings along the water. In the background is a single skyscraper.

69. Stieglitz's October 1911 issue of *Camera Work*, no. 36, included sixteen of his prints. *City of Ambition* (fig. 13), p. 5, and *Old and New New York* (fig. 12), p. 15.

70. A sketch for *Interior of the Fourth Dimension*, incorrectly dated 1914, is in the collection of the Baltimore Museum of Art.

71. Max Weber, "The Fourth Dimension From a Plastic Point of View," *Camera Work*, no. 31 (July 1910): 25. See p. 95 of this catalogue.

72. David Nye in *The Electrification of America*, 62, described an event in 1909 that may have triggered Weber's painting of this special illumination of the harbor. To celebrate the three hundredth anniversary of Henry Hudson's exploration of the Hudson River, "the bridges of the East River were outlined in lights, with thirteen thousand used on the Brooklyn Bridge alone. Every public building from City Hall to Grant's tomb was decked out in lights, and the entire shoreline . . . was ablaze. The famous Colgate sign, seen by all ferry passengers to and from New Jersey each day, was rewired so that beside the clock sailed a

full sized replica of Hudson's Half Moon with waves dashing against it."

73. Nye, *The Electrification of America*, 73.

74. Quoted in *Max Weber*, introduction by Alfred H. Barr, Jr., p. 17.

75. "More Post Impressionism," *New York Times*, February 18, 1912, Weber Papers, AAA (NY59-6), 387.

76. Dominic Ricciotti identified the serpent shapes in *New York* as the elevated trains in "The Revolution in Urban Transport: Max Weber and Italian Futurism," *The American Art Journal* 41, no. 1 (Winter 1984): 53.

77. Coburn subscribed to the press cutting agency Romeike and Curtice, so that Weber could receive articles from the Grafton Group exhibition. "Artist Cult of the Horrible: Exhibition of Wild Eccentricities," probably from *The London Times*, was sent to Weber for his clipping file, Weber Papers, AAA (NY59-6), 400.

78. "More Post Impressionism: Exhibition of the Alpine Gallery," *The Standard*, March 20, 1913, Weber Papers, AAA (NY59-6), 399.

79. Alfred Thornton, "Editorial: Post Impressionism," *Observer*, April 6, 1913, Weber Papers, AAA (NY59-6), 397.

80. Letter from Coburn to Weber, April 6, 1915, Weber Papers, AAA (N69-85), 411.

81. Quoted in *Max Weber*, introduction by Alfred H. Barr, Jr., p. 17.

82. Dominic Ricciotti, "City Railways/Modernist Visions," in Susan Danly and Leo Marx, eds., *The Railroad in American Art: Representations of Technological Change* (Cambridge: MIT Press, 1988), 132.

83. Weber's pastel *In an Automobile*, 1912, was included in his retrospective exhibition at the Montross Gallery in New York, December 14-30, 1915. An unidentified critic in "Art and Artists: Interesting Exhibit of Max Weber's Odd Work," *New York Globe*, December 1915, Weber Papers, AAA (NY59-6), remarked: "A pastel entitled "In an Automobile," leads one to presume that Mr. Weber has been speeding, as only the most rapid movement conceivable could produce such an effect upon the mind."

84. Letter from Coburn to Weber, January 29, 1913, Weber Papers, AAA (N69-85), 285.

85. [Henry McBride?], untitled review of Weber's show at the Montross Gallery, *The Sun* (New York), December 19, 1915, Weber Scrapbooks, collection Joy S. Weber.

86. "Max Weber's Zeal in Imitation," unmarked article, 1915, Weber Papers, AAA (NY59-6), 371.

87. "Baltimore," review of Weber's show at the Jones Gallery, Baltimore, March 1915, Weber Papers, AAA (NY59-6), 369.

88. J. O. L., "Three Arts: Weber's Paintings Striking Examples of Art of the Secessionists," *The Sun* (Baltimore), March 1915, Weber Papers, AAA (NY59-6), 348.

89. "Maker of Curious Pictures in Town," review of Weber's show at the Jones Gallery, *Evening News* (Baltimore), March 1915, Weber Papers, AAA (NY59-6), 359.

90. Letter from Weber to van Noppen, December 20, 1921, Weber Papers, AAA (NY59-8), 194.

91. "Max Weber's Plastic Fantasies," review in unidentified publication, February 1915, Weber Papers, AAA (NY59-6), 371.

92. Max Weber, "The New Humanity in Modern Art," *New York Call*, May 25, 1919, 2-3.

93. Letter from Weber to van Noppen, November 14, 1919, Weber Papers, AAA (NY59-8), 184.

94. Brochure advertising Weber's class on art history and appreciation at the Clarence H. White School of Photography, 1917,

95. Untitled review of *Essays on Art*, in *The Nation*, April 1917, Weber Papers, AAA (NY59-6), 469.

96. Max Weber, *Essays on Art* (New York: William Edwin Rudge, 1916), 11.

97. Ibid., 12.

98. Ibid., 29.

99. Letter from Weber to van Noppen, July 16, 1916, Weber Papers, AAA (NY59-8), 145.

100. Letter from Gleizes to Weber, October 2, 1919, Weber Papers, AAA (NY59-7), 582-83.

101. Henry McBride, untitled review of first Independent exhibition, *The Sun* (New York), April 22, 1917, Weber Papers, AAA (NY59-6), 379.

102. Jacob Kainen, "Max Weber, Dean of American Modernists, on Exhibition," review of Weber's retrospective exhibition at the New Art Circle, *Daily Worker*, December 6, 1937, Weber Scrapbooks, collection Joy S. Weber.

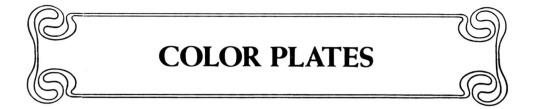

# COLOR PLATES

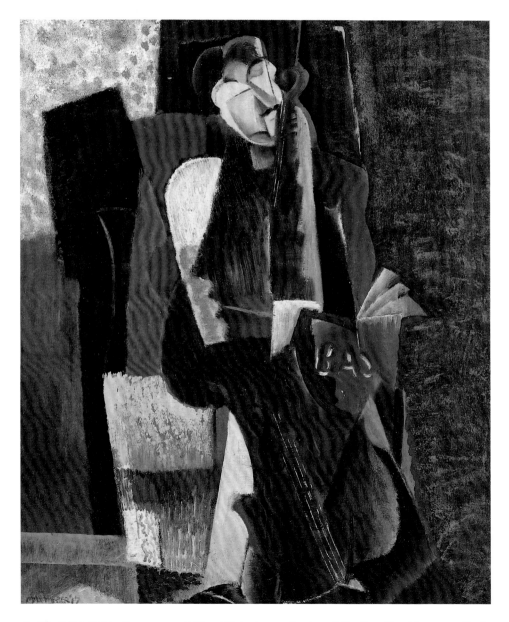

61. *The Cellist*, 1917, oil on canvas, 20⅛ x 16⅛ inches, collection of The Brooklyn Museum; gift of Mrs. Edward Rosenberg.

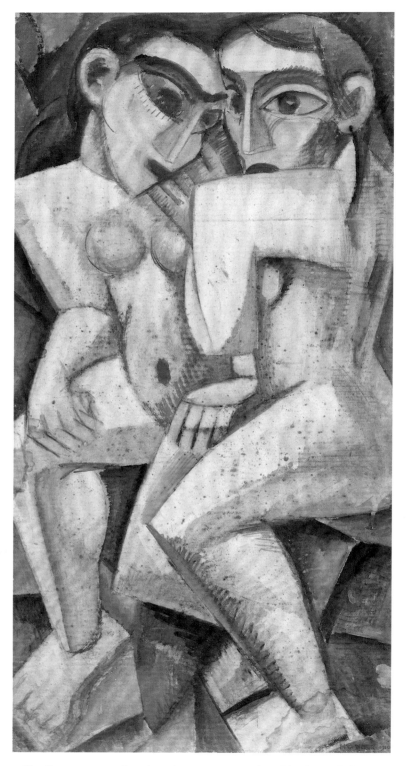

7. *Two Figures*, 1910, oil on board, 47½ x 24½ inches, The Regis Collection, Minneapolis.

11. *Figure Study*, 1911, oil on canvas, 24 x 40 inches, collection of the Albright-Knox Art Gallery, Buffalo; C. W. Goodyear Fund, 1959.

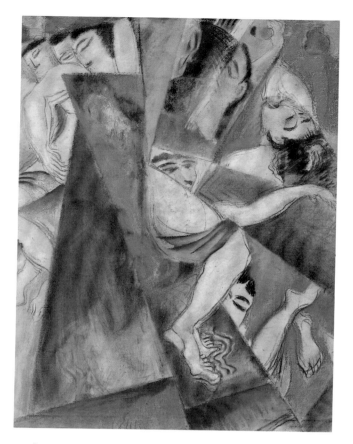

20. *Dancers*, 1912, gouache, pastel, and pencil on board, 24³/₄ x 18⁵/₈ inches, collection of Mr. and Mrs. Harvey Silverman, New York.

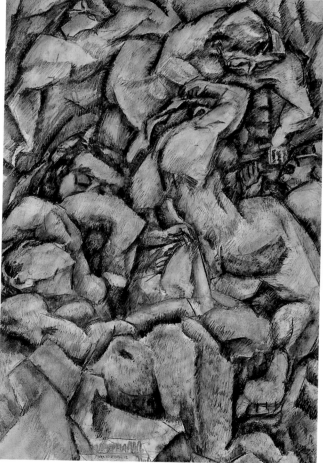

28. *Order Out of Chaos*, 1912, gouache on board, 18½ x 12¼ inches, collection of Lionel Kelly, England.

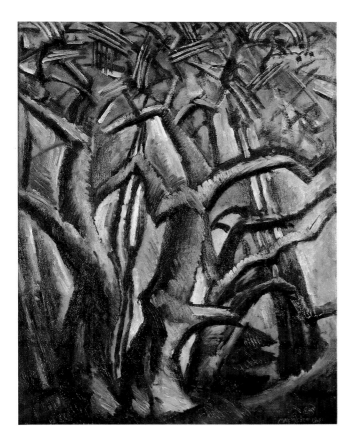

16. *Trees*, 1911, oil on canvas, 28 x 22 inches, collection of Michael Scharf.

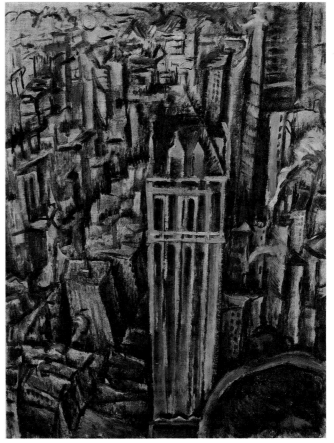

27. *New York (The Liberty Tower from the Singer Building)* [*The Woolworth Building*], 1912, oil on canvas, 18 x 12¾ inches, collection of the Museum of Fine Arts, Boston; gift from the Stephen and Sybil Stone Foundation.

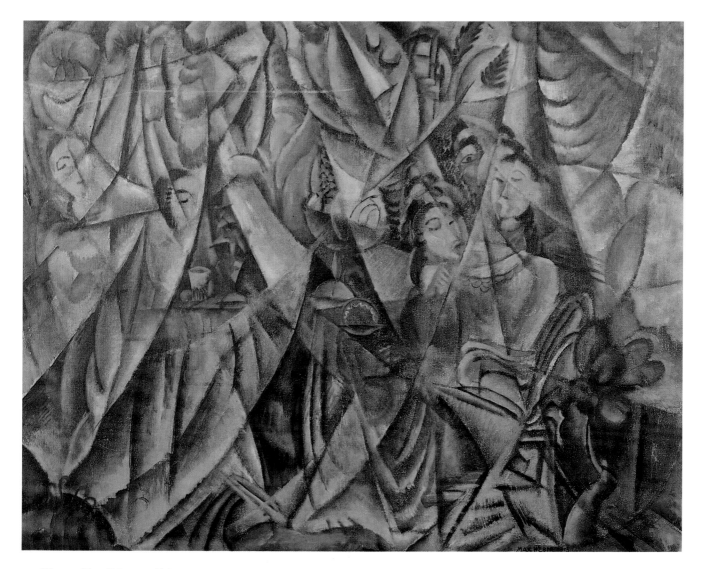

42. *Women in Tents* [*Woman and Tents*], 1913, oil on canvas, 30 x 36 inches, private collection, in memory of Helen M. Obstler.

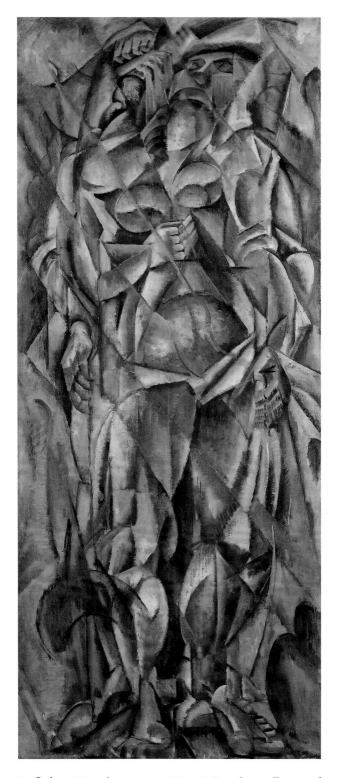

34. *Bather*, 1913, oil on canvas, 60⅝ x 24⅜ inches, collection of
the Hirshhorn Museum and Sculpture Garden, Smithsonian
Institution, Washington, D.C.; gift of Joseph H. Hirshhorn,
1966.

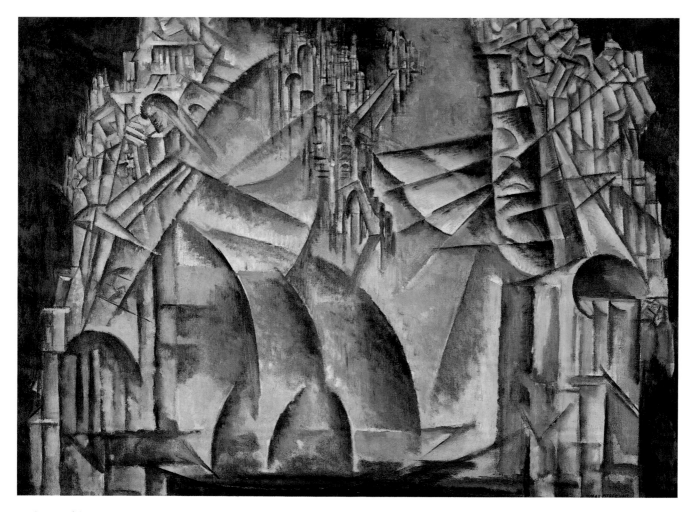

37. *Interior of the Fourth Dimension*, 1913, oil on canvas, 30 x 39½ inches, collection of the National Gallery of Art, Washington, D.C.; gift of Natalie Davis Spingarn, in memory of her grandmother, Linda R. Miller.

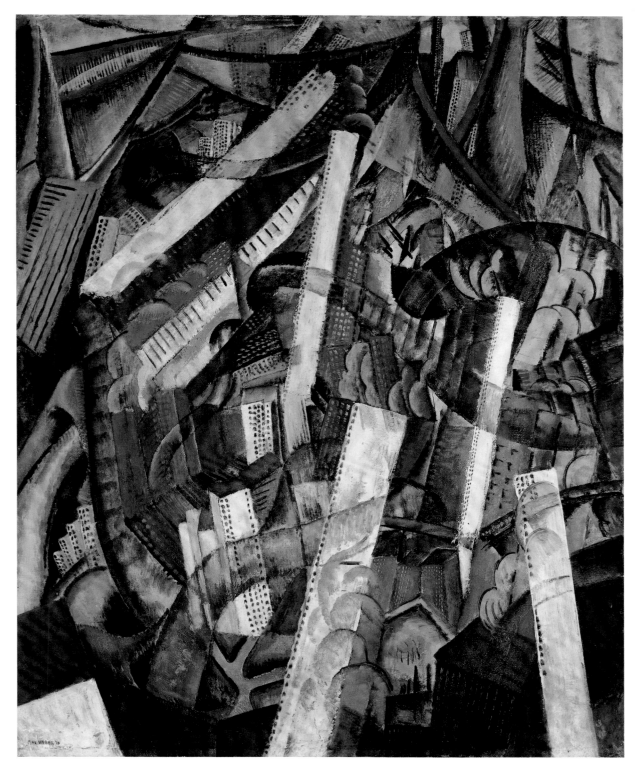

38. *New York*, 1913, oil on canvas, 40⅝ x 32½ inches, Thyssen-Bornemisza Collection, Lugano, Switzerland.

40. *Sunday Tribune*, 1913, pastel on newsprint, 23¾ x 16¾ inches, courtesy Forum Gallery, New York.

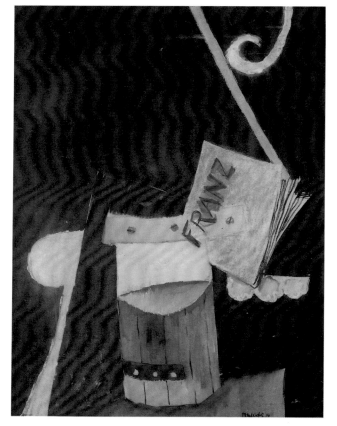

47. *Music Recital*, 1914, gouache and pastel on paper, 24 x 18 inches, Fayez Sarofim Collection.

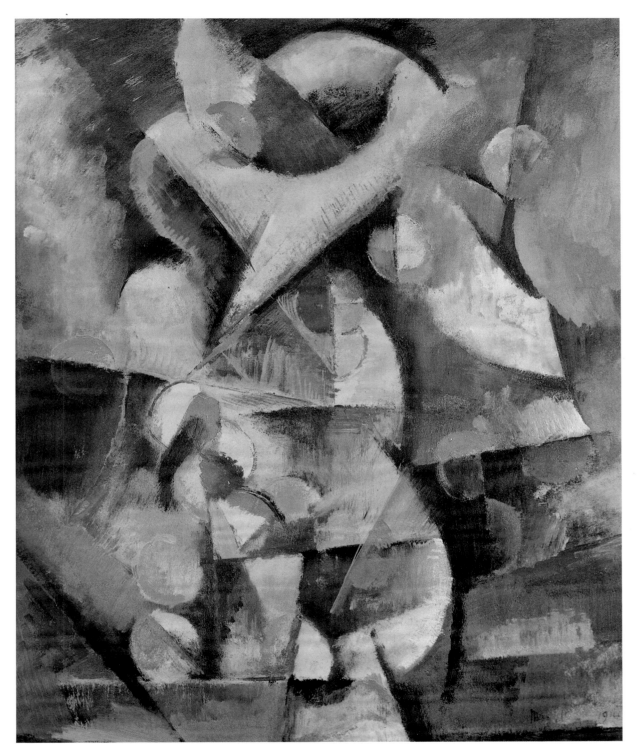

45. *Color in Motion*, 1914, oil on board, 20¾ x 16⅝ inches, collection of Michael Scharf.

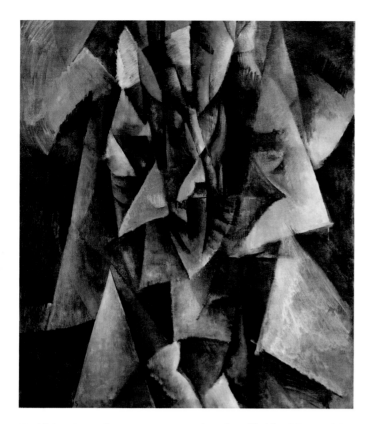

56. *Night*, 1915, oil on canvas, 48 x 40¼ inches, Sheldon Memorial Art Gallery, University of Nebraska–Lincoln; NAA-Nelle Cochrane Woods Memorial Collection.

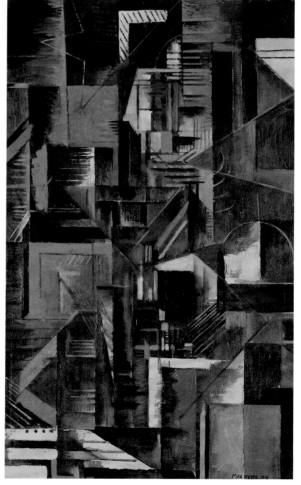

54. *New York at Night*, 1915, oil on canvas, 33⅞ x 20¹/₁₆ inches, collection of The Archer M. Huntington Art Gallery, The University of Texas at Austin; lent by James and Mari Michener.

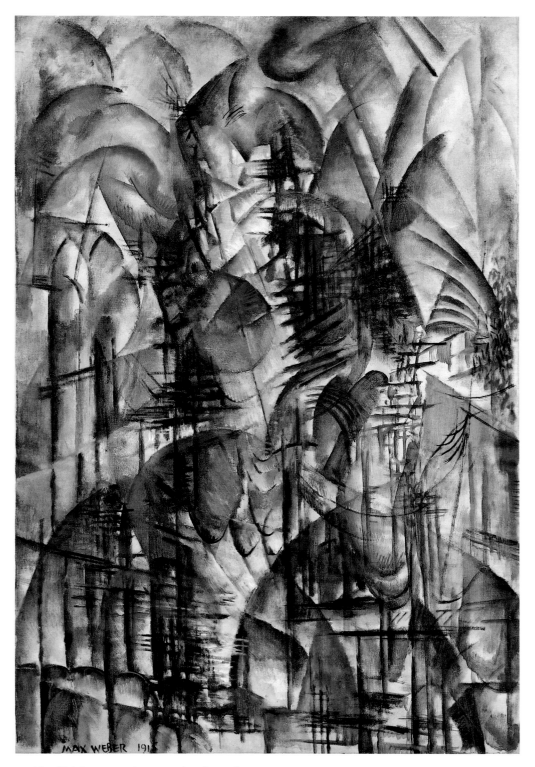

55. *New York Department Store* [*An Idea of a Modern Department Store*], 1915, oil on canvas, 46³⁄₈ x 31 inches, collection of The Detroit Institute of Arts; Founders Society Purchase, Mr. and Mrs. Walter Buhl Ford II Fund.

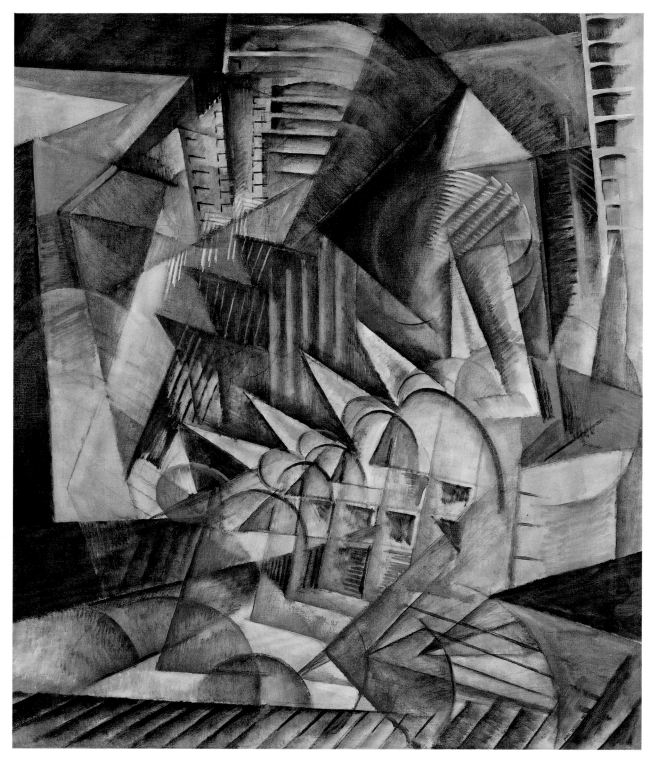

57. *Rush Hour, New York*, 1915, oil on canvas, 36¼ x 30¼ inches, collection of the National Gallery of Art, Washington, D.C.; gift of the Avalon Foundation.

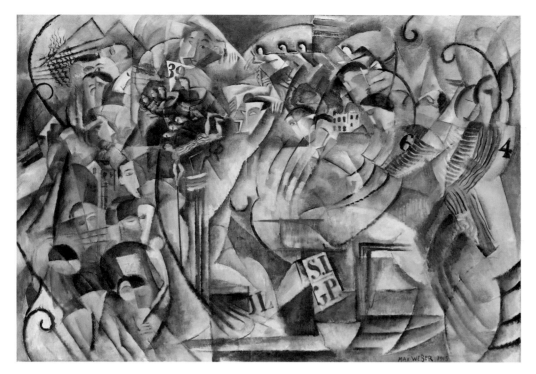

49.
*Athletic Contest [Interscholastic Runners]*, 1915, oil on canvas, 40½ x 55¼ inches, collection of The Metropolitan Museum of Art, New York; George A. Hearn Fund, 1967 (67.112).

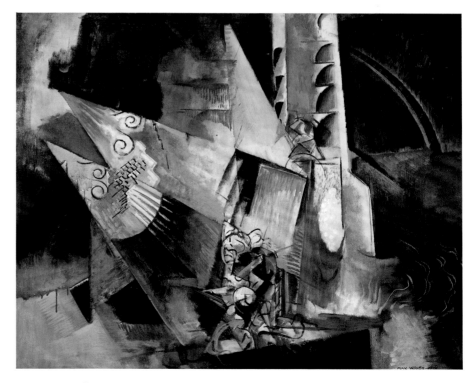

60. *Russian Ballet*, 1916, oil on canvas, 30 x 36 inches, Edith and Milton Lowenthal Collection.

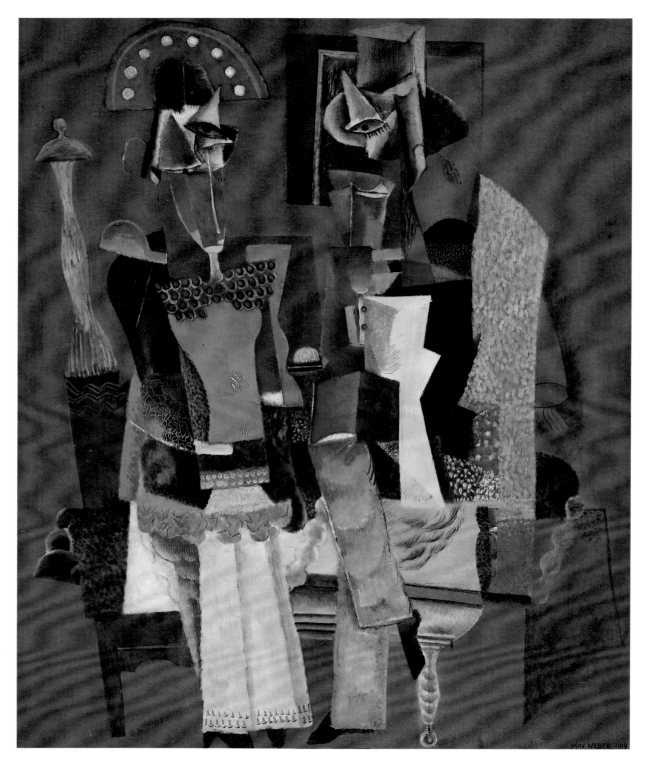

74. *Conversation*, 1919, oil on canvas, 42 x 32 inches, collection of the McNay Art Museum, San Antonio, Texas; purchase.

# ILLUSTRATIONS

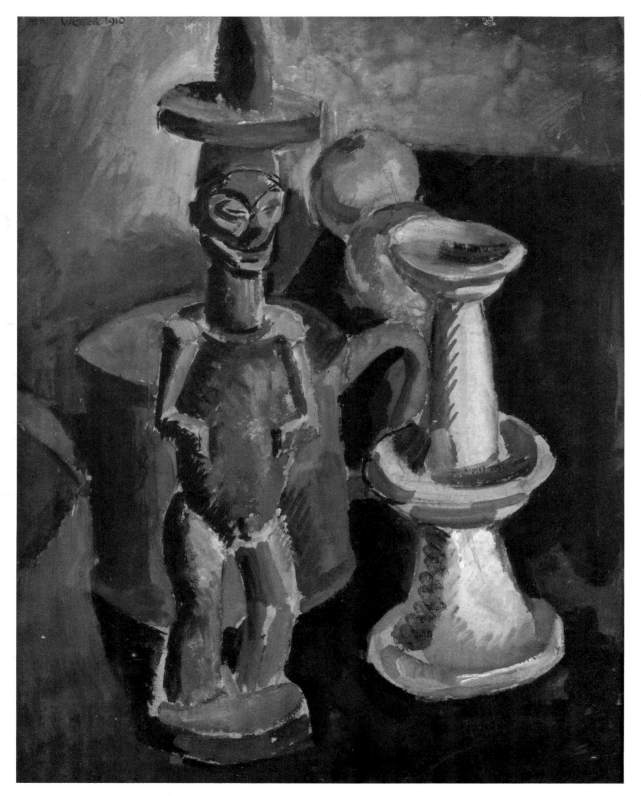

1. *African Sculpture* [*Congo Statuette*], 1910, gouache on board, 13½ x 10½ inches, courtesy Forum Gallery, New York.

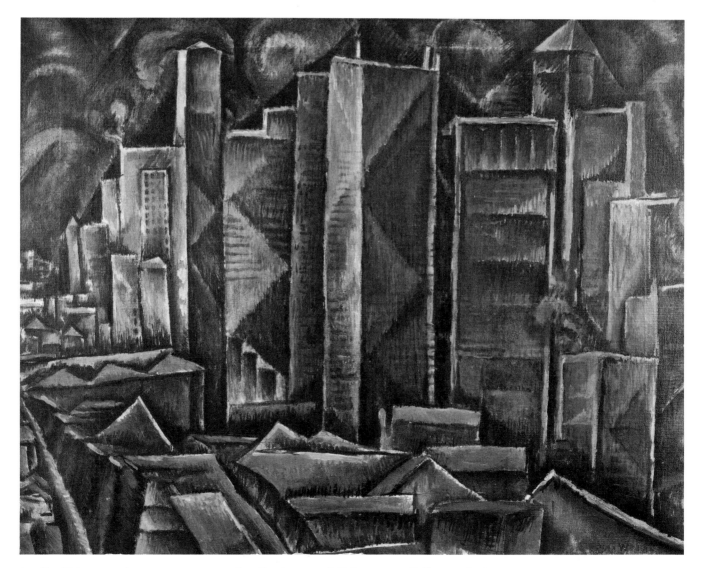

24. *New York*, 1912, oil on canvas, 21 x 25 inches, Southwestern Bell Corporation Collection, St. Louis.

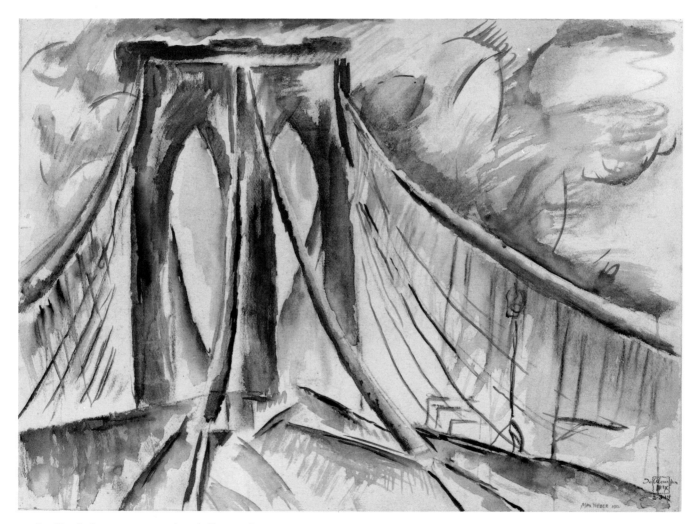

18. *Brooklyn Bridge*, 1912, watercolor, chalk, and charcoal on paper, 19 x 24½ inches, collection of Lionel Kelly, England.

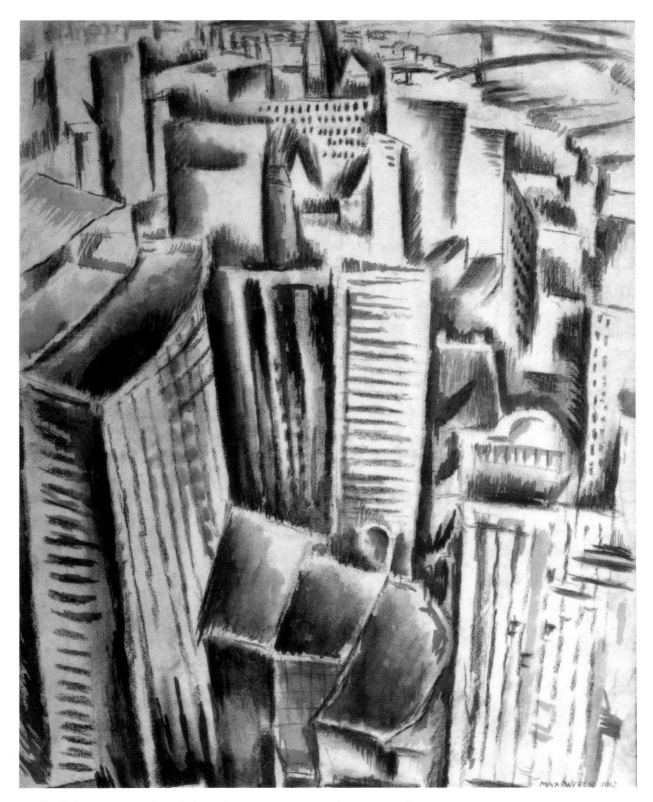

25. *New York*, 1912, watercolor and charcoal on paper, 24½ x 19 inches, private collection.

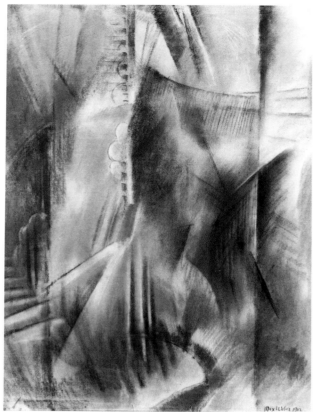

23.
*Music*, 1912, pastel on paper, 23½ x 17¼ inches,
private collection.

39. *The Screen*, 1913, pastel on paper, 19 x 25 inches, private collection.

32. *Abstraction*, 1913, pastel and collage on paper, 24 x 18½ inches, collection of the New Britain Museum of American Art, Connecticut; Charles F. Smith Fund.

33. *Abstraction* [*Nude Descending a Staircase*], 1913, charcoal and pastel on paper, 24⁷/₁₆ x 18⁵/₈ inches, collection of the Yale University Art Gallery, New Haven, Connecticut; gift of Walter L. Ehrich.

31. *Abstract Machine Forms*, 1913, pastel on paper, 24½ x 18¾ inches, collection of Mr. and Mrs. Leonard J. Plotch, Boca Raton, Florida.

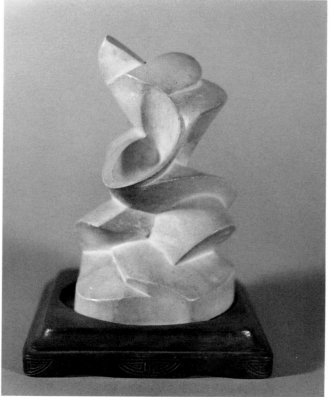

58. *Spiral Rhythm*, 1915, plaster, 5⅜ x 3⅛ x 3⅛ inches, private collection, in memory of Helen M. Obstler.

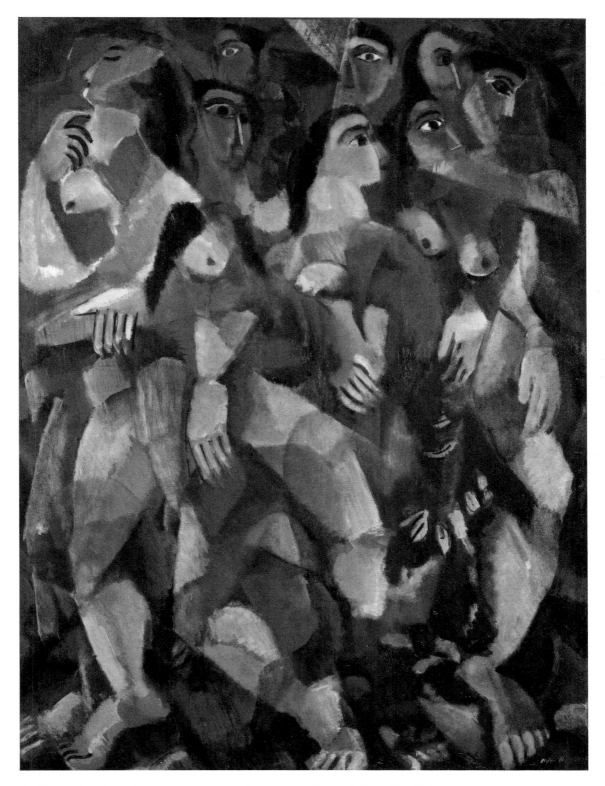

41. *Tapestry #1*, 1913, oil on canvas, 40 x 30 inches, courtesy Forum Gallery, New York.

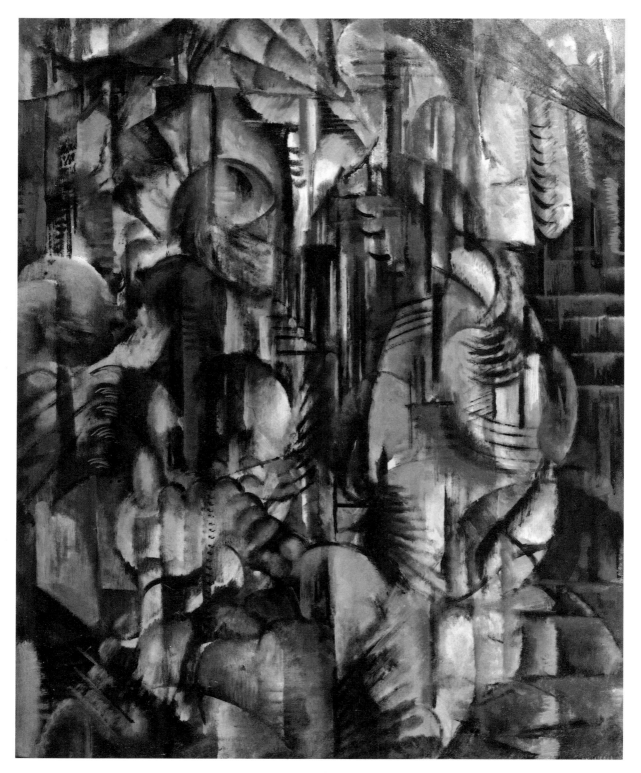

48. *New York*, 1914, oil on canvas, 35½ x 29½ inches, The Regis Collection, Minneapolis.

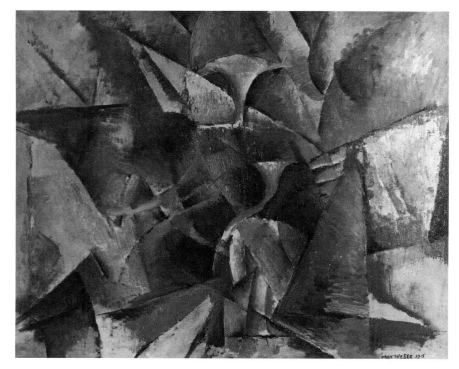

52.
*Construction*, 1915, oil on canvas, 22⅞ x 27⅞ inches, collection of the Terra Museum of American Art, Chicago.

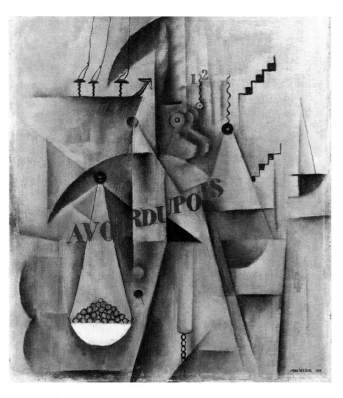

50. *Avoirdupois*, 1915, oil on canvas, 21¼ x 18¼ inches, collection of the Baltimore Museum of Art; Mabel Garrison Siemonn Fund, in memory of her husband, George Siemonn, by exchange.

63. *Interior with Women*, 1917, oil on canvas, 18 x 23 inches, collection of Mr. and Mrs. Meredith J. Long.

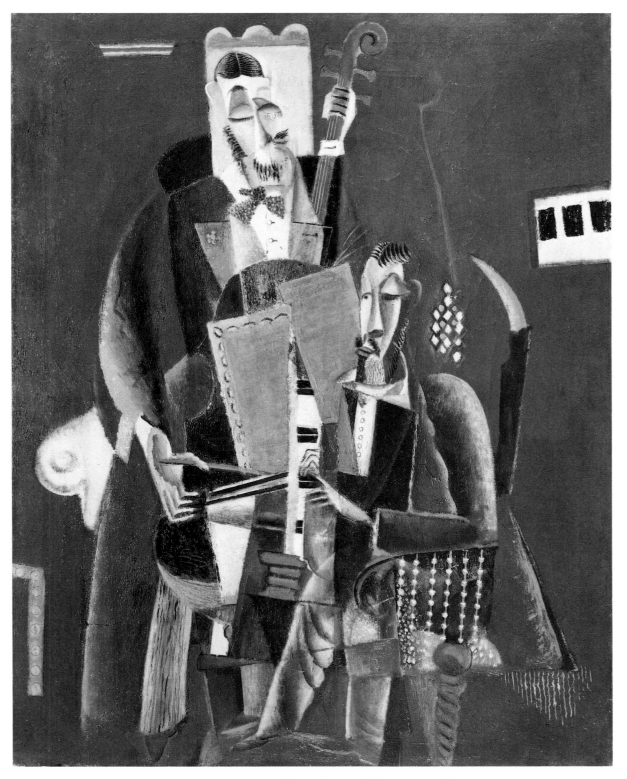

69. *The Two Musicians*, 1917, oil on canvas, 40⅛ x 30⅛ inches, collection of The Museum of Modern Art, New York; acquired through the Richard D. Brixey Bequest, 1944.

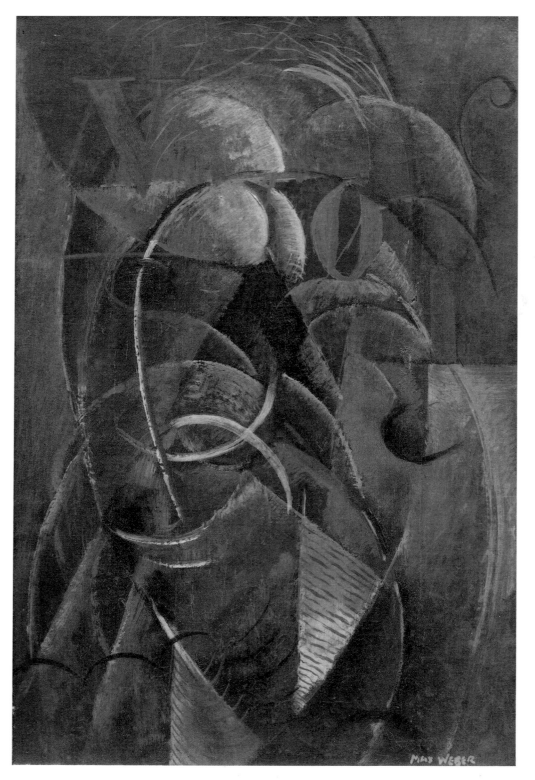

71. *Voices*, 1917, oil on canvas, 16 x 10 inches, collection of Joy S. Weber.

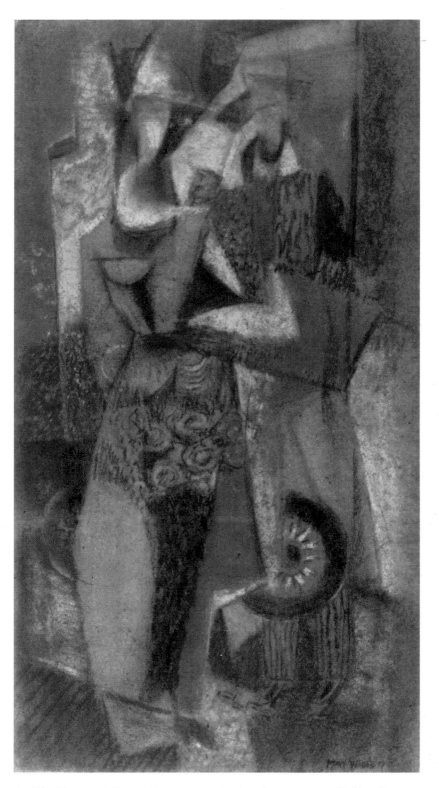

64. *The Meeting*, 1917, pastel on paper, 17 x 8 inches, courtesy Sheldon Ross Gallery, Birmingham, Michigan.

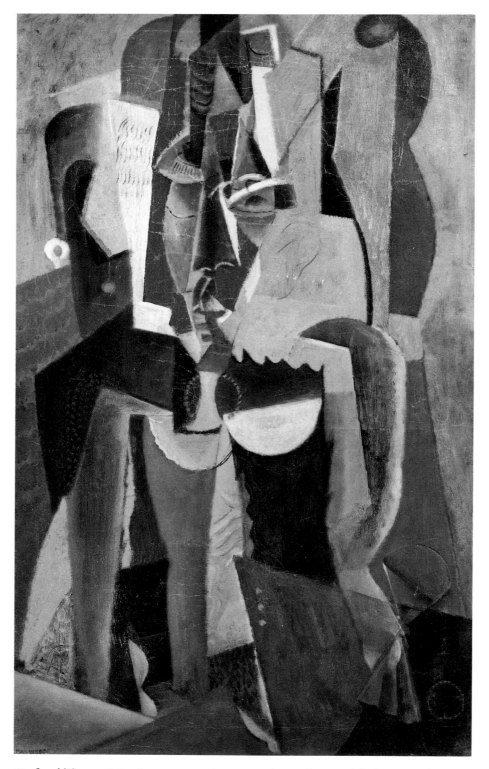

68. *Seated Woman*, 1917, oil on canvas, 40⅛ x 24¼ inches, collection of the Rose Art Museum, Brandeis University, Waltham, Massachusetts; gift of Mrs. Max Weber and her children, Maynard and Joy, Great Neck, New York, in memory of Max Weber.

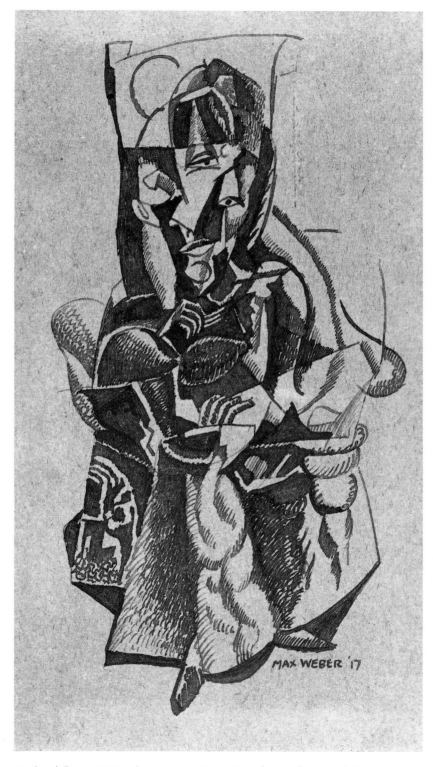

67. *Seated Figure*, 1917, ink on paper, 9¾ x 6⅛ inches, collection of the Fogg Art Museum, Harvard University, Cambridge, Massachusetts; bequest of Meta and Paul J. Sachs.

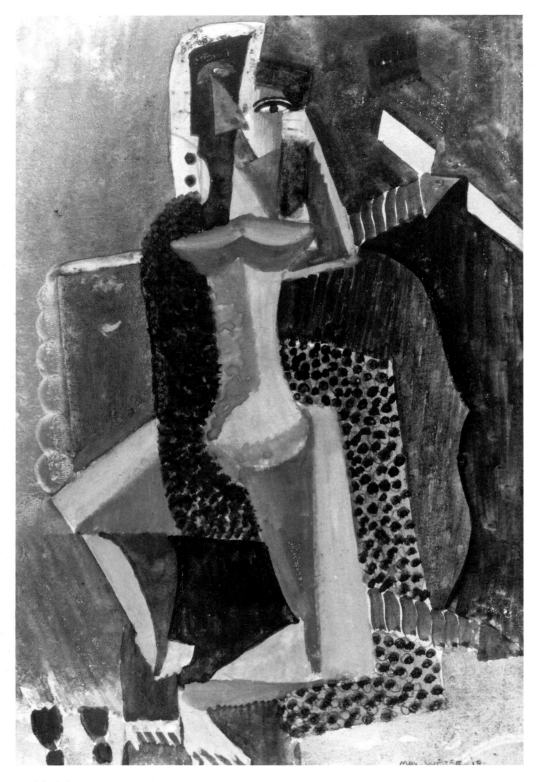

73. *The Embrace*, 1918, gouache on paper, 8³/₁₆ x 5³/₈ inches, collection of Dr. Harold and Elaine L. Levin.

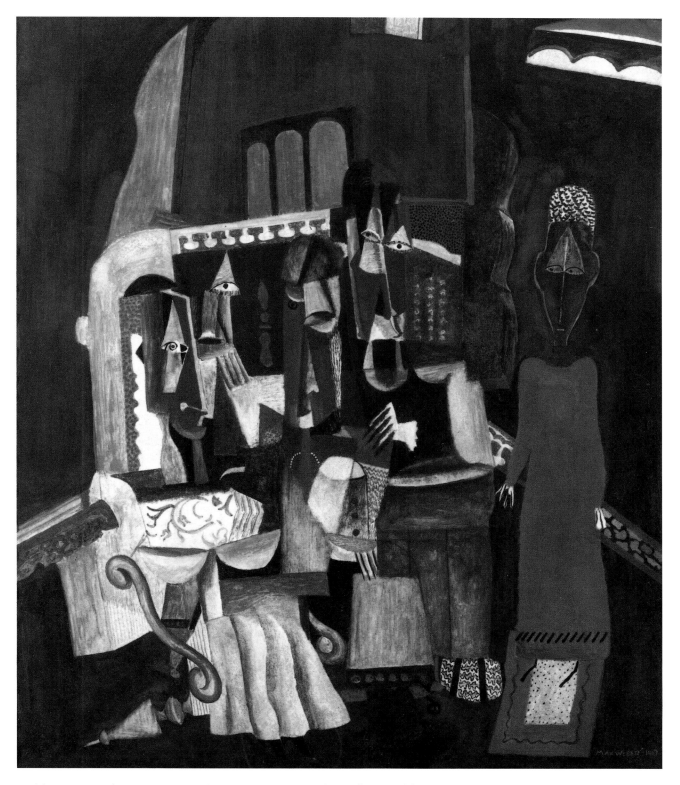

70. *The Visit (A Family Reunion)*, 1917, oil on board, 36¼ x 30 inches, collection of the Corcoran Gallery of Art, Washington, D.C.; museum purchase through a gift of Mrs. Francis Biddle.

72. *The City*, 1918, pastel on paper, 23⅝ x 18⅛ inches, collection of the Joslyn Art Museum, Omaha.

# CHRONOLOGY

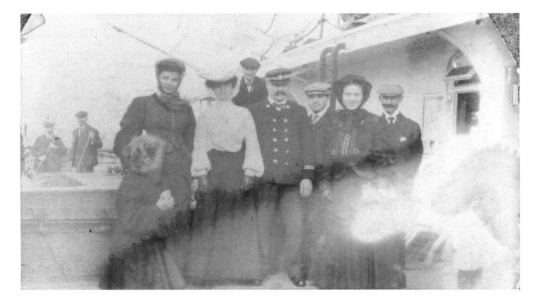

Fig. 22: Anonymous, photograph of Weber (third from right) on the steamer Krumland, ca. September 21, 1905, platinum print, 3⅛ x 5½ inches, collection of Joy S. Weber.

Born in Bialystok, Russia, in 1881, Max Weber immigrated to the United States at the age of ten. He settled in the Williamsburg section of Brooklyn, where he attended local public schools and then the Pratt Institute. From 1901 to 1903 he taught construction drawing and manual training in public schools in Lynchburg, Virginia, and from 1903 to 1905 he taught at the State Teachers College in Duluth, Minnesota. Weber sailed from New York to Paris, then the world's art center, in September of 1905.

While in Paris Weber absorbed the lessons of Cézanne and Matisse and befriended the young American painters Samuel Halpert and Abraham Walkowitz, the Spanish artist Pablo Picasso, and the French artists Robert Delaunay and Henri "Le Douanier" Rousseau. He exhibited in the avant-garde Parisian Salon d'Automne and the Salon des Indépendants. In 1908 he attended Matisse's Saturday painting critiques, which he had helped to organize. At the end of 1908, Weber left Europe. He arrived in New York in January of 1909 and embarked on the most challenging decade of his career.

Fig. 23: Anonymous, Max Weber in his studio at 7 Rue Belloni, Paris, ca. 1907 - 8, gelatin-silver copy print, collection of Joy S. Weber.

## 1909

■ After forty months in Europe, Weber returns to New York in January. Lives in a studio with Abraham Walkowitz. Spends summer in a barn on Long Island. Visit to Coney Island results in paintings of vaudeville.

■ Weber's first one-artist exhibition at Haas Gallery (April 22-May 8), from which Arthur B. Davies purchases two paintings.

■ Isadora Duncan performs at the Metropolitan Opera in November. Weber produces several small drawings based on it.

■ Exhibited at 291: Alvin Langdon Coburn's photographs (January 18-February 1), paintings by John Marin and Alfred Maurer (March 30-April 17), paintings by Marsden Hartley (May 8-May 18).

Figs. 24, 25: Invitation (cover and inside) for Rousseau's soirée in honor of Max Weber, 1908, collection of Joy S. Weber.

■ F. T. Marinetti's "Manifeste du futurisme" published in *Le Figaro* (February 20).

■ Arthur Dove returns to New York from Paris. Robert Henri opens Robert Henri School of Art at the Lincoln Arcade building, New York.

■ Gertrude Stein's *Three Lives* (New York: Grafton Press), her first work in print, is published. Sergei Diaghilev founds Ballets Russes in Paris.

## 1910

■ Weber lives at 8 East 23rd Street, New York. Visits Alfred Stieglitz at Deal Beach, New Jersey, during summer. Meets Photo-Secession photographers Alvin Langdon Coburn and Clarence H. White.

■ Exhibits in *Younger American Painters* at 291, along with D. Putnam Brinley, Arthur B. Carles, Arthur Dove, Lawrence Fellows, Marsden Hartley, John Marin, Alfred Maurer, and Eduard Steichen (March 9-March 21).

■ Designs installation of *International Exhibition of Pictorial Photography* at the Albright Art Gallery, Buffalo (November 3-December 1), largest and last event of the Photo-Secession. Commissioned to paint portrait of gallery owner N. E. Montross; rejected due to its Cézannesque distortions, the portrait is destroyed.

■ Presents lecture, "Photography," to White's class at Columbia University. "The Fourth Dimension From a Plastic Point of View" and "Chinese Dolls and Modern Colorists" published in *Camera Work*.

■ Henri Rousseau dies, September 2. Weber lends drawings by Rousseau to memorial exhibition he initiates at 291 (November 18-December 8).

■ *The Independent Artists Exhibition*, organized by Davies, William Glackens, Henri, Walt Kuhn, Everett Shinn, and John Sloan, held at 29 West 35th Street, New York (March 26-April 21).

■ Work by the Grafton Group included in *Manet and the Post-Impressionists*, organized by painter and critic Roger Fry, at the Alpine Club Gallery, London (November-January 1911).

■ Coburn's photographic book *New York*, with a foreword by H. G. Wells, published by Duckworth & Co. Press, London.

■ First issue of *Der Sturm* published by Herwarth Walden, Berlin.

■ "Manifesto dei Pittori Futuristi," published in *Poesia* (February 11), signed by Umberto Boccioni, Carlo Carra, Luigi Russolo, Gino Severini, Arnolo Bonzagni, and Romolo Romani.

■ Gelett Burgess's "The Wild Men of Paris," in *Architectural Record*, presents interviews with modern artists and includes first illustrations of cubist paintings published in the United States. Temple Scott's "Fifth Avenue and the Boulevard Saint-Michel" in *Forum* expresses the ideas of Michael Weaver (Max Weber).

# 1911

■ Weber lives at 10 East 14th Street in Greenwich Village. One-artist exhibition of drawings and paintings at 291 (January 11-31). Agnes Ernst Meyer purchases painting. Ends association with Stieglitz.

■ Painting trip in Connecticut with Arthur Dove in March. Designs installation of *Modern Photography* at the Newark Museum, New Jersey (April 6-May 4). Exhibits *Still Life* in *Paintings by American Artists*, Union League Club (April 13-15). Paints portrait of Coburn.

■ Coburn photographs Weber for *Men of Mark* (London: Duckworth & Co., 1913). Coburn's "The Relation of Time to Art" published in *Camera Work* 36 (October): 72-73.

■ Exhibited at 291: first exhibition of Picasso drawings and watercolors (March 28-April 25), watercolors by Gelett Burgess, author of "Wild Men of Paris" (November 7-December 8).

■ Cubists exhibit in Salon des Indépendants and Salon d'Automne.

■ *Die Erste Austellung der Redaktion Der Blaue Reiter* at the Galerie Tannhäuser, Munich (December 18), includes work of *Der Blaue Reiter* editors Wassily Kandinsky, Franz Marc, and Gabriel Munter and invited artists including Rousseau and Delaunay.

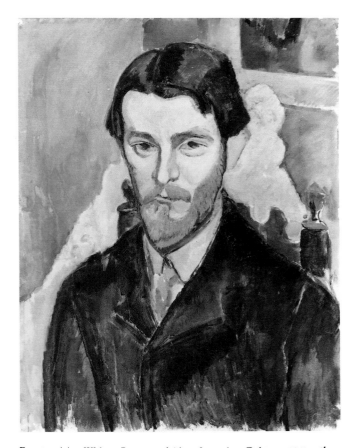

Fig. 26: Max Weber, Portrait of Alvin Langdon Coburn, 1911, oil on board, 24 x 18½ inches, collection of Lionel Kelly, England.

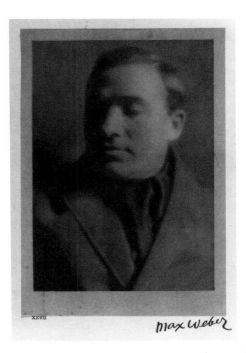

Fig. 27: Alvin Langdon Coburn, *Portrait of Max Weber*, 1911, from *Men of Mark* (New York: Mitchell Kennerly, 1913), plate XXVII.

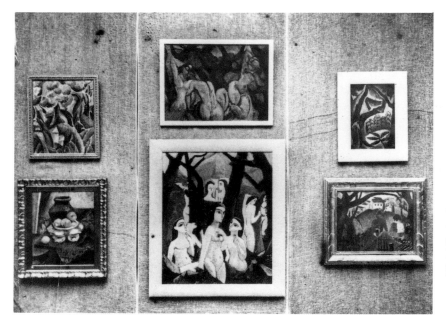

Fig. 28: Alvin Langdon Coburn, installation of Max Weber's exhibition at Murray Hill Gallery, New York, February 12-24, 1912, gelatin-silver copy print, collection of Joy S. Weber.

# 1912

■ Weber has one-artist show at Murray Hill Gallery, New York (February 12-24). Exhibits three pastels at Powell Art Gallery, New York (February 19-March 9). Designs installation of *An Exhibition Illustrating the Progress of the Art of Photography in America*, Montross Art Galleries, New York (October 10-31).
■ Weber moves to 1442 Charlotte Street in the Bronx in April. Davies introduces Weber to Maurice Prendergast. Mabel Dodge purchases three paintings, writes to Weber:

> It is a great pleasure to me to have your picture & I find more & more in it. It is a fine composition & of a whole quality of color. I hope to see something of you next winter in New York where I am coming to live—at 23 Fifth Avenue—3rd floor up. You were able to explain things so well that you have won Mr. Field over to the side of all those who are trying to see with fresh eyes.[1]

■ Exhibited at 291: Carles paintings (January 18-February 3), Dove's first one-artist show of pastels, early examples of non-objective paintings by an American (February 27-March 12), Hartley paintings and drawings (February 7-26), and Matisse sculpture and drawings (March 14-April 6).
■ In Paris Picasso and Braque begin working in collage. Robert Delaunay refers to his color-oriented cubist work as Orphism. Duchamp paints *Nude Descending a Staircase*. Albert Gleizes and Jean Metzinger's *Du Cubisme* published by Eugène Figuière. First exhibition of Futurist painters, *Les Peintres Futuristes Italiens*, is held at Galérie Bernheim-Jeune (February 5-24).
■ The second Blue Rider exhibition, *Die Zweite Austellung der Redaktion Der Blaue Reiter*, held at Der Neue Kunst salon in February, including graphics by Picasso, Braque, Delaunay, Mikhail Larionov, and Natalia Goncharova, in addition to the Blue Rider artists.
■ Wassily Kandinsky's *Über das Geistige in der Kunst: insbesondere in der Malerie* is published (Munich: R. Piper & Co.). (Translated as *On the Spiritual in Art*, it had major impact on modernism in America.) "Extracts From the Spiritual in Art" printed in *Camera Work*, no. 39 (July): 34.
■ Gertrude Stein's word portraits of Matisse and Picasso published in *Camera Work*, Special Number (August): 23-25, 29-30.
■ Grand Central Station opens in New York.

Fig. 29: Weber (second from right) in automobile, anonymous platinum print, collection of Joy S. Weber.

# 1913

■ Weber lives at 520 East 79th Street, New York. Spends summer in Pleasantville, New York, writing poetry. Sends eleven paintings to Grafton Group exhibition at the Alpine Club Gallery, London (March 15-31).

■ Designs installation of sixty-two casts of historical sculpture for the Newark Museum. During same summer, has one-artist exhibition at the Newark Museum, first solo museum exhibition of a modern American painter: "Whatever may be the fate of this development in art, it is today of sufficient importance, if only because of the tempest it has aroused, to warrant all sensible persons in giving its products a little careful observation and a little serious thought."[2]

■ "The Filling of Space" published in *Platinum Print*.

■ *International Exhibition of Modern Art*, Armory of the 69th Regiment, New York (February 17-March 15), introduces broad spectrum of modern art to American audiences. Selections travel to the Art Institute of Chicago (March 24-April 16) and Copley Hall, Boston (April 28-May 19). Weber does not participate, but lends Rousseau paintings.

■ Mabel Dodge initiates her "Evenings" at 23 Fifth Avenue:

> [These events were] a combination of town meeting, bohemian Chautauqua, and cocktail party. What made them important was the fact that they served the needs of a community that was just beginning to identify itself, . . . Socialists, Trade-Unionists, Anarchists, Suffragists, Poets, Lawyers, Murderers, Newspapermen, Artists, Clubwomen, Woman's-place-is-in-the-home Women, Clergymen, and just plain men.[3]

■ Coburn's *Men of Mark*, with portraits of Weber and Clarence White, among others, published by Duckworth & Co., London. Coburn exhibits photographs of *New York From Its Pinnacles*, taken in 1912, at Goupil Gallery, London.

■ Exhibited at 291: Francis Picabia's sixteen New York studies (March 17-April 5), Walkowitz drawings and paintings (December 15-January 14).

■ First exhibitions of American synchromists, *Austellung der Synchromisten S. Macdonald-Wright, Morgan Russell*, at Der Neue Kunstsalon, Munich (June 1-30); *Les Synchromistes: Morgan Russell et S. Macdonald-Wright*, at Galérie Bernheim-Jeune, Paris (October 27-November 8).

■ Guillaume Apollinaire's *Les Peintres Cubistes: Méditations esthétiques* is published in Paris by Eugène Figuière.

■ The Woolworth Building, the tallest building in the world at 792 feet, is completed in April. D. W. Griffith's *Judith of Bethulias* is released.

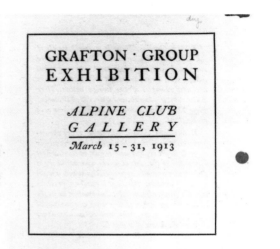

Figs. 30, 31: Brochure for the Grafton Group Exhibition, 1913, collection of Joy S. Weber.

Fig. 32: Alvin Langdon Coburn, Max Weber on the Pallisades, 1911, platinum print, 4 x 3⅛ inches, collection of Joy S. Weber.

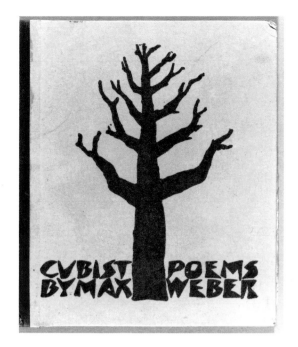

Fig. 33: Max Weber, cover of *Cubist Poems* (London: Elkin Mathews, 1914), 6½ x 5⅜ inches, collection of Joy S. Weber.

Fig. 34: Weber (second row, second from right) with students from The Clarence H. White School of Photography, ca. 1914-16, anonymous platinum print, 7¼ x 9½ inches, collection of Joy S. Weber.

## 1914

■ Weber begins teaching art history, art appreciation, and design at the Clarence H. White School of Photography, 122 East 17th Street, New York. One of founding members of school, he teaches until 1918. Teaches summer class in modern art at Seguinland, Five Islands, Maine, July 6-August 15.

■ Weber moves to 30 Charles Street. *Cubist Poems* published in London by Elkin Mathews.

■ Poem, "The Workmass," published in *The Sun* (New York), September 5, 1914.

■ Gertrude Vanderbilt Whitney organizes exhibitions at her studio at 8 West 8th Street to support independent artists. Establishes Whitney Studio Club, which later becomes the Whitney Museum of American Art.

■ First synchromist exhibition in New York, *Exhibition of Synchromist Paintings by Morgan Russell and S. Macdonald-Wright*, Carroll Galleries, New York (March 2-16).

■ Exhibited at 291: Hartley's paintings (January 12-February 14), eight sculptures by Constantin Brancusi (March 12-April 4), eighteen African sculptures (November 3-December 8), Picasso and Braque paintings and drawings (December 9-January 11).

■ Wyndham Lewis's *Blast No. 1: Review of the Great English Vortex* published in London by John Lane. F. T. Marinetti's *Manifesti del Futurismo* published by Lacerba, Florence.

# 1915

■ Weber exhibits paintings and drawings at the Print Gallery (The Ehrich Galleries), New York (February 1-13), and considers this his first success. Meets William Zorach and begins life-long friendship. Nathan J. Miller purchases *Interior of the Fourth Dimension*, 1913 (cat. 37) for his wife, Linda, beginning lifelong patronage.

■ Paintings exhibited at Jones Galleries, Baltimore (March):

> "Aren't you a futurist?" he was asked.
> "I am not," he said indignantly.
> "What, then, a cubist?"
> "Certainly not! I am Max Weber. My sole desire is to express myself; to paint not what I see with my eye but with my consciousness. My work now is entirely subjective. . . ."
> "What I want to do now is to produce in terms of pigment my mental impressions, not a mere literal, matter-of-fact copying of line and form. I want to put the abstract into concrete terms."[4]

■ Weber moves to 125 Washington Place in July. Photo of Weber by Clarence White in *Vanity Fair 5* (September): 36.

■ Weber paintings and sculpture exhibited at Montross Gallery, New York (December 14-30), including *A Comprehension of the Grand Central Terminal*, 1915 (fig. 18), *An Idea of a Modern Department Store*, 1915 (cat. 55), *Interior with Music*, 1915, *Interscholastic Runners*, 1915 (cat. 49), *Memory of a Chinese Restaurant*, 1915 (cat. 51), *New York at Night*, 1915 (cat. 54), *Night*, 1915 (cat. 56), *Rush Hour, New York*, 1915 (cat. 57), the major production of his cubist decade.

■ Only exhibition of Vorticist group, organized by Wyndham Lewis at Dore Galleries, London (May). *Panama-Pacific International Exposition*, San Francisco (February 20-May 1, 1916), features Italian Futurist paintings for first time in United States.

Fig. 36: Catalogue of an exhibition of paintings and drawings by Max Weber at The Print Gallery, New York, February 1-13, 1915.

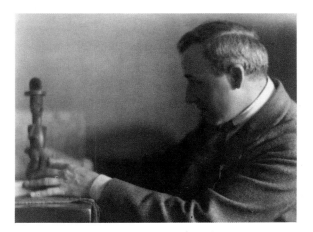

Fig. 35: Clara E. Sipprell, Max Weber with *African Sculpture*, ca. 1914-16, platinum print, 7¼ x 9¼ inches, collection of Joy S. Weber.

Fig. 37: Arthur D. Chapman, Max Weber with *Spiral Rhythm*, 1915, platinum print, 8¹/₁₆ x 6¹/₁₆ inches, collection of Joy S. Weber.

Fig. 38: Cover of *Essays on Art* (New York: William Edwin Rudge, 1916), 10 x 7- ³/₈ inches, collection of Joy S. Weber.

■ Weber marries Frances Abrams on June 27. They settle at 15 Seaman Avenue, Dyckman, New York.

■ *Carrying Fruit*, 1916, *Potatoes*, 1916, and *An Indian Basket*, 1916, exhibited in the *Post Exposition Exhibition* at the Panama-Pacific Exposition, San Francisco (January 1-May 1). *Philadelphia's First Exhibition of Advanced Modern Art*, McClees Galleries (May 17-June 15), includes Weber's *Lecture Phantasy*, 1916.

■ Exhibits "a small picture from 1910" at the Corcoran Gallery of Art in Washington, D.C. Weber Papers, AAA (NY59-6), 376.

■ *Essays on Art* published by William Edwin Rudge, New York:

> The essays embody the philosophy he has evolved through his art experience as a modern painter. The essays are not what generally pass for historical or even aesthetic art-criticism, but are such original creations in literature as one met with few and far between.[5]

■ *Forum Exhibition of Modern American Painters*, Anderson Galleries (March 13-13), includes works by Ben Benn, Thomas Hart Benton, Oscar Bluemner, Andrew Dasburg, Dove,

Fig. 39: Alvin Langdon Coburn, untitled vortograph, 1917, copy made by Coburn for the 1961 Reading Coburn exhibition, 23½ x 18 inches, collection of the English Department, University of Reading, England.

Hartley, Macdonald-Wright, Marin, Maurer, H. L. McFee, George F. Of, Man Ray, Morgan Russell, Charles Sheeler, Walkowitz, and William and Marguerite Zorach. Weber is invited to exhibit by organizer John Weichsel, but he declines.[6]

■ Exhibited at 291: drawings and watercolors by Walkowitz (February 14-March 12), paintings by Hartley (April 4-May 22), Georgia O'Keeffe drawings for first time (May 23-July 5).

■ Coburn experiments with prism in camera, creating abstract photographs (later called vortographs), which resemble Weber's prismatic paintings of 1912.

## 1917

■ Weber's father dies in March.

■ *Special Exhibition: Arthur B. Davies, Walt Kuhn, Jules Pascin, Charles Sheeler, Max Weber* at the Montross Gallery, New York (February 13-March 3), includes twenty-seven paintings by Weber.

■ Society of Independent Artists holds first exhibition in Grand Central Palace, New York (April 10-May 6). Marcel Duchamp submits *The Fountain* (a urinal), causing a scandal. Weber's *Women and Tents*, 1913 (cat. 42) and *Chinese Restaurant*, 1915 (cat. 51) exhibited, with the titles changed.

■ *Labor* and *Still Life* included in *Exhibition of Paintings by The "Moderns,"* Vassar College, Poughkeepsie, New York (December 5-21).

■ Exhibited at 291: Marsden Hartley's recent work (January 22-February 7), John Marin's watercolors (February 14-March 3), Gino Severini paintings, drawings, pastels (March 6-17). *Recent Work by Georgia O'Keeffe* (April 3-May 14) is the last exhibition at 291; Stieglitz closes gallery and publishes last issue of *Camera Work*.

■ Theo van Doesburg's *de Stijl* review first published in Leiden. Jean Cocteau writes, Erik Satie composes, and Sergei Diaghilev stages the ballet *Parade*, with costumes and sets by Picasso.

## 1918

■ Weber lives at 66 Post Avenue, New York. Mother dies in April.

■ Weber serves as a director of Society of Independent Artists for one year. *Women Seated*, 1913, and *Still Life* listed in catalogue for *Society of Independent Artists Exhibition* at 110-114 West 42nd Street, New York (April 20-May 12). *Imaginative Portrait of a Woman*, 1913 (cat. 35), published in *The Sun* (New York), April 21, 1919. Prints series of cubist-inspired woodblocks carved from honey boxes. Abandons teaching at White School of Photography.

**The Clarence H. White School of Photography**

122 East Seventeenth Street
(The Old Washington Irving House)
New York City
1917

FOURTH SEASON
LECTURES ON THE HISTORY
OF ART AND ART APPRECIATION
by MR. MAX WEBER
Wednesdays from 10:45 A. M.—12 M.
Fee $30.00.

ON Wednesday, November 14th, Mr. Max Weber will deliver the first of a series of twenty-five lectures on the history of art, embracing the various works in painting sculpture and allied arts, from the earliest epochs schools and masters, including the phases of modern art. The lectures are profusely illustrated with significant examples discernibly and logically chosen from an extensive collection of slides.

The lectures are interpretative in character, and greater emphasis is laid throughout the entire course upon the intrinsic plastic significance and intent of art, than upon historic and erudite data.

Apply to
CLARENCE H. WHITE
122 East Seventeenth Street
New York City

Figs. 40, 41: Brochure for The Clarence H. White School of Photography, 1917, collection of Joy S. Weber.

## 1919

■ *Special Exhibition of Pictures,* Montross Gallery (January 4-24), includes Weber's *Repose, A Head, Bathers,* and *Mother and Child. Musicians* is exhibited in *Paintings by Contemporary American Artists,* Parish House, Church of the Ascension, New York (April 21-May 21). *Annual Exhibition of Modern Art Arranged by a Group of European and American Artists in New York,* Bourgeois Galleries (May 3-24), includes Weber's *A Head, The Dyckman, The Song,* and *The Cellist,* 1917 (cat. 61).

■ Weber donates *Nudes* and *Landscape* to the *Call Bazaar* at the New Star Casino to benefit the socialist journal *The New York Call* (May 29-June 1). Contributes foreword to catalogue—extracts from an essay entitled "Reconstruction of Old Ideas through Modern Art"—and serves as chairman of artists committee with Ben Benn, John Sloan, and William Zorach. Serves on members committee for the *Exhibition of American Painting and Sculpture at the Luxembourg Museum,* Paris (October-November). Although his work is sent to Paris, the French do not exhibit the modernist American entries.

■ Paints *Red Cross Nurse,* 1919, for exhibition in temporary arch at public library in New York to encourage donations to the Red Cross. Critiques life drawing classes at the Art Students League until 1921.

■ Publishes "The New Humanity in Modern Art," *The New York Call* (May 25): 2-3, in which he writes: "Art is the universal tongue of mankind."

■ The Bauhaus founded in Weimar, Germany.

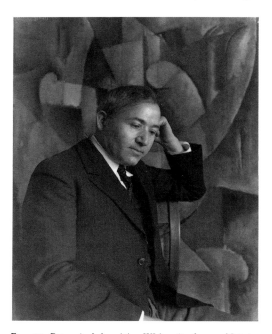

Fig. 42: Peter A. Juley, Max Weber (in front of *Interior with Music,* 1915), ca. 1930, gelatin-silver print, 9½ x 7½ inches, collection of Joy S. Weber.

## 1920

■ Weber's *Still Life* included in *A Selected Group of Modern French and American Paintings* at the Colony Club, New York (March 26-April 4). *My Studio in Paris,* 1907, is included in *Exhibition of Modern Art by Contemporary Artists* at the Worcester Art Museum, Massachusetts (April 25-May 16). *Still Life, Interior with Figures,* and twenty-four woodcuts included in *Special Exhibition, Works by Eighteen American Artists* at Montross Gallery (May 11-29).

■ Daniel-Henry Kahnweiler's explanatory text on Cubism, *Der Weg zum Kubismus,* is published (Munich: Delphin Verlag).

By 1920, Weber's position as an important artist was established; only later did he achieve popularity as well as acclaim. His work appeared regularly in exhibitions and was discussed by critics. In 1924, he was honored with a retrospective exhibition at the prestigious Galérie Bernheim-Jeune in Paris.

Weber's personal life became more stable during the 1920s with the financial support of Mrs. Nathan J. Miller. In 1921, he and his wife bought a house in suburban Nassau Haven, Long Island; the Webers' children Maynard and Joy were born in 1923 and 1927. Weber returned to teach at the Art Students League in 1926, but teaching distracted him from painting and he stayed for only one year.

Weber was included in the second exhibition at the Museum of Modern Art, *Paintings by Nineteen Living Americans,* in 1929, and was honored with a retrospective exhibition at the museum the next year. Politically active during the 1930s, Weber became the National Chairman of the American Artists Congress in 1937. He received honors and awards throughout his life, such as major retrospective exhibitions at the Whitney Museum of American Art in 1949, the Jewish Museum in 1956, and the Newark Museum in 1959. He received honorary doctorates at Brandeis University in 1957 and at his alma mater, Pratt Institute, in 1959. Upon his death in 1961 Max Weber was acclaimed as the "Dean of American Moderns."

PERCY NORTH

## NOTES

1. Weber Papers, AAA (N69-83), 166.
2. John Cotton Dana, "Paintings by Max Weber," *The Newark Museum Bulletin* 3, no. 1 (July): 1-5.
3. Steven Watson, *Strange Bedfellows: The First American Avant-Garde* (New York: Abbeville Press, 1991), 136.
4. "Maker of Curious Pictures in Town," *Baltimore Evening News,* Weber Papers, AAA (NY59-6), 3599.
5. B. S. Barker, *Works by Max Weber,* brochure published by Clarence White to advertise Weber's books, Weber Scrapbooks, collection Joy S. Weber.
6. Weber Papers, AAA (N60-1), 473.

# SELECTED WRITINGS
# BY MAX WEBER

## THE FOURTH DIMENSION FROM A PLASTIC POINT OF VIEW

In plastic art, I believe, there is a fourth dimension which may be described as the consciousness of a great and overwhelming sense of space-magnitude in all directions at one time, and is brought into existence through the three known measurements. It is not a physical entity or a mathematical hypothesis, nor an optical illusion. It is real, and can be perceived and felt. It exists outside and in the presence of objects, and is the space that envelops a tree, a tower, a mountain, or any solid; or the intervals between objects or volumes of matter if receptively beheld. It is somewhat similar to color and depth in musical sounds. It arouses imagination and stirs emotion. It is the immensity of all things. It is the ideal measurement, and is therefore as great as the ideal, perceptive or imaginative faculties of the creator, architect, sculptor, or painter.

Two objects may be of like measurements, yet not appear to be of the same size, not because of some optical illusion, but because of a greater or lesser perception of this so-called fourth dimension, the dimension of infinity. Archaic and the best of Assyrian, Egyptian, or Greek sculpture, as well as paintings by El Greco and Cézanne and other masters, are splendid examples of plastic art possessing this rare quality. A Tanagra, Egyptian, or Congo statuette often gives the impression of a colossal statue, while a poor, mediocre piece of sculpture appears to be the size of a pin-head, for it is devoid of this boundless sense of space or grandeur. The same is true of painting and other flat-space arts. A form at its extremity still continues reaching out into space if it is imbued with intensity or energy. The ideal dimension is dependent for its existence upon the three material dimensions, and is created entirely through plastic means, colored and constructed matter in space and light. Life and its visions can only be realized and made possible through matter.

The ideal is thus embodied in, and revealed through the real. Matter is the beginning of existence; and life or being creates or causes the ideal. Cézanne's or Giotto's achievements are most real and plastic and therefore they are so rare and distinguished. The ideal or visionary is impossible without form; even angels come down to earth. By walking upon earth and looking up at the heavens, and in no other way, can there be an equilibrium. The greatest dream or vision is that which is *regiven* plastically through observation of things in nature. "Pour les progrès à réaliser il n'y a que la nature, et l'oeil s'éduque à son contact." Space is empty, from a plastic point of view.

The stronger or more forceful the form the more intense is the dream or vision. Only real dreams are built upon. Even thought is matter. It is all the matter of things, real things or earth or matter. Dreams realized through plastic means are the pyramids and temples, the Acropolis and the Palatine structures; cathedrals and decorations; tunnels, bridges, and towers; these are all of matter in space—both in one and inseparable.[1]

## CHINESE DOLLS AND MODERN COLORISTS

I have seen Chinese dolls, Hopi Katcinas images, and also Indian quilts and baskets, and other works of savages, much finer in color than the works of the modern painter-colorists. Yet the dolls were very modest and quiet about their color, not to speak of their makers; and their makers knew they were making dolls and toys and were satisfied at that. But at the *Salon d'Automne*, and the *Salon des Artists Indépendants*, the canvases of some of the color masters seem to shriek out, "Why, the whole universe depends upon me! Don't you know that?" And pretty soon a mob gathers in front, and on all sides of these masterly colored pieces, and all join the chorus in unison. This is so even with the very poorly colored paintings as long as they are in red and green, blue and yellow, or other scientific harmonies, freshly squeezed from the pure tubes. But the purely colored doll, with its intense and really beautiful color and form, is nothing but a pleasing toy, while a Cézanne or a Renoir, with its marvelously rare and saturated, yet grey colored forms, is a masterpiece, and a very unpretentious and distinguished one. —I'll take a Cézanne and keep my Chinese doll.

There are today painters who lay open the tubes upon their canvases, according to the laws of modern chromatics, then step upon them until the canvas is well and purely covered, and uncovered canvas is a happy accident. After this marvelous achievement they expect trees, pots, heads, figures, or other forms, and even *l'expression absolue*, to grow out of these colored steps. Impossible! No smear of Veronese green, juxta-

posed with one vermilion, or other formless complementary daubs or splashes, however brilliant in color, can ever take the place of even the dullest toned or moderately colored painting that has form. There can be no color without there being a form, in space and in light, with substance and weight, to hold the color. I prefer a form, even if it is in black and white, rather than a *tache* of formless color. And as we think of these matters, we question: "Will there ever be a science of art?"[2]

## ON THE BROOKLYN BRIDGE

This morning early I was on the old Bridge of this New York. Midst din, crash, outwearing, outliving of its iron and steel muscles and sinews, I stood and gazed at the millions of cubes upon billions of cubes pile upon pile, higher and higher, still piled and still higher with countless window eyes, befogged chimney throats clogged by steam and smoke—all this framed and hurled together in mighty mass against rolling clouds—tied to space above and about by the infinitely numbered iron wire lines of the bridge, spreading interlacedly in every angle. Lulled into calm and meditation (I gazed) by the rhythmic music of vision (sight) I gazed and thought of this pile throbbing, boiling, seething, as a pile after destruction, and this noise and dynamic force created in me a peace the opposite of itself. Two worlds I had before me the inner and the outer. I never felt such. I lived in both![3]

## UNTITLED ESSAY, 1912

This is a wonderful age we are living in now. Everyone has more creative liberty. The creative mind finds new ways and stops at no law laid down by, or piled upon us by lesser or non-creative minds. The real self is desired that the personal become universal, and a new reaching out from one to all is hoped for; a new contact even with the past. It is great to live now! It is harder, but what of that? The hunger we have now! This new embrace of the universe. This great blending of various forms of expression.

Surely there will be new numbers, new weights, new colors, new forms, new odors, new sounds, new echoes, new rhythm of energy, new and bigger range of our sense capacities; we will find new measures, new proportions, new intervals, and we shall yet subject matter to greater and newer thought, and we materalize the now intangible, the now untouchable. I can feel that there are things about things we do not yet know, that we shall yet know and think. We shall yet find new material exterior equivalents for the inner, for the psychic, for our imagination, for our memory. We shall paint with the mind eye, the thought eye, after that which the real has seen. We shall not be bound to visible objects—only the essence we as humans get out of them. We shall put together that which in the material sense is quite impossible, but in thought,—

Matter in mind is like liquid,
Time, millions of years is thought of in one
    second; in one flash,
Mountains moved, symphonies heard,
Memories are visible things.

Probably the new religion, the new love, the new order, the new love of life will be shaped by this new thought. One can't tell, and it is good not to say no, but to live and to anticipate, and apprehend—to penetrate the infinite.

I know there is a new world in art to come out of this one—the psycho-plastic, psycho-pictorial, or why art? A new world of existence, of being, of living. [4]

# THE FILLING OF SPACE

Photography is flat space art, as is drawing, painting or printing. The page or the canvas is empty, but pregnant with birth as is space, waiting for the touch of the inspired mind. There is a universe of light and colored form in matter—forms of matter in the several kingdoms of nature.

It lies within the domain of the plastic arts to reorganize forms, to reconstruct and interpret nature, to create or realize forms and visions of forms, unit by unit. And intervals between—the interval, the mind pause, the contemplation, the generating energy make yield the material whether in two or three dimensions, for matter yields in measure with and in degree of the intensity of the creative power of the artist or artisan.

In our choice and elimination lies the very character of our personality, the very quality of our taste and expression. In our appreciation and discard, lies our sense of values, of proportion, of relationship—material and psychic. These are the fundamental and profoundest means for the not-so-immediate results, as distinct from trifling so-called principles essentially worthless and non-creative, that produce automatic and immediate results—if results they be. All that is of intrinsic worth is infinite.

By reason of the lens being an indispensable instrument in the work of the artist-photographer, matter or nature, or scenes in nature are less yielding and flexible to his medium than to the living sensitive human eye, guided by and controlled with the mind, mood, and time. The mind guides the hand, and all other senses are brought into play through spiritual contact and tactile intimacy with sound, light, motion, color, form; and the vision or phantasy after that.

The photographer's art lies supremely in his choice or disposition of visible objects, as prompted and guided by his intellect and his taste. His mind is his screen. He may shift objects, he may choose his position, he may vary the spaces between movable objects, and finally he may vary the proportion and size of the rectangle bounding the picture or print. After this, he may display rare quality and great skill in the particular art of printing and developing, emphasizing or subduing thereby, tones and contours.

The artist in photography, artists in other graphic arts, and laymen as well, have equal access to enjoy, to study and to assimilate some unfailing principles of plastic beauty and truth in objects found in the best museums. Along with this, experience through untiring work in, and a great love for photography.

Further than this, there is no recipe to the art of space filling in photography, as there is no recipe to any art; or to the very Art of Life. [5]

# FROM CUBIST POEMS

### The Eye Moment

CUBES, cubes, cubes, cubes,
High, low, and high, and higher, higher,
Far, far out, out, out, far,
Planes, planes, planes,
Colours, lights, signs, whistles, bells, signals, colours,
Planes, planes, planes,
Eyes, eyes, window eyes, eyes, eyes,
Nostrils, nostrils, chimney nostrils,
Breathing, burning, puffing,
Thrilling, puffing, breathing, puffing,
Millions of things upon things,
Billions of things upon things
This for the eye, the eye of being,
At the edge of the Hudson,
Flowing timeless, endless,
On, on, on, on. . . .

### Bampense Kasai

MASK Bampense Kasai,
Crudely shaped and moulded, art thou,
In weighty varied solid frightful form,
Through thy virility brutality and blackness,
I gain insight subtle and refined.
Then 'tis true Kasai that the sculptor in thy making
Was not the jungle savage,
But high spirited and living soul.
In carving thy features Bampense Kasai,
In the crudest geometric form,
Thy savage maker makes an art
At once untrifling big and powerful.
Surely not ignorance but fear and love and spirit high,
Made him make you Bampense Kasai.

### Oh Sun

OH sun to thee it is to make all visible,
Under thy rays of light
Lies this great city of cubic form—New York.

## Chac-Mool of Chichen-Itza

CHAC-MOOL of Chichen-Itza,
So art thou imbued with energy of vision
That thy stare leaves all behind thee as thou hast and
   always wilt.
Thy stare into the future with unequalled velocity
Thou wert made once so, to witness all that passes and
   all that shall pass.
Thy time endless, one breath of thine, the intervals
   between the opening and the closing of thine
   eyelids
Is a great part of eternity.
Thy weight and power was made to endure and bear,
Thou wilt stand the fiercest storm, heat, cold,
Thou wilt suffer and conquer, change, time, emotion, sorrow
All will pass and come again to go again, endlessly thus
But thou art eternal, thou art the sign of eternity.
Thou wilt see all and know all always.
The cup thou holdest so firmly in thy powerful and
   untrembling hands,
Shall forever receive the raindrops from gentlest
   shower to the waters of the maddest cloud-
   burst.

## The Silhouette

ALONE in dim light
Smoky suthed lamp behind
Enclosed by one shingle weather-eaten wall
And three net screens
Alone,
Though here screens and I
Lamp and I
Silhouette and I
Enclosed by darkness opaque
Wrapped in vibrating layers of night
Motion and sound stilled,
Darkness waiting for light
In stillness and dimness I hear the light
I hold which darkness hides
I bear which weight dispenseth
So vague!
Still.
Only memory of memory remembers,
Darkness waiting is pregnant with light,
Waiting, vague, vacuous, still
Silence itself asleep.
Screen vanish, vanish screen!
And my silhouette on thee vanish
Deceit and eyes' illusion vanish
Vanish!
The shadow of the real brings mystery
Vanish silhouette!
I am here without thee,

Inner, inner all innerness in me
And all from me without thee
Ghastly ghostly thou silhouette
I stir and thy distortion after me stirs
I am real!
My light makes thee dark
My intention, my meaning, thy pretence is
Vague, mimic, non-tactile thou art,
Silhouette vanish![6]

# NOTES

1. Published in *Camera Work*, no. 31 (July 1910): 51.
2. Published in *Camera Work*, no. 31 (July 1910): 25.
3. Manuscript, 1912, Weber Papers, AAA (NY 59-6), 136. Weber sent Alvin Langdon Coburn this text, to which he referred in his letter to Weber, January 1, 1914, Weber Papers, AAA (N69-85), 330. Published in Percy North, *Max Weber: American Modern* (New York: Jewish Museum, 1983).
4. Manuscript, Weber's introduction to pamphlet for *Exhibition of Paintings and Watercolors at the Modern School*, New York, April 23-May 7, 1913, Weber Papers, AAA (NY 59-6), 134-35. Copy of pamphlet in Scrapbook 10, Mabel Dodge Luhan Archive, Collection of American Literature, Beinecke Rare Book and Manuscript Library, Yale University, New Haven, Connecticut.
5. Published in *Platinum Print* 1 (December 1913): 6.
6. Published in *Cubist Poems* (London: Elkin Mathews, 1914), 11, 14, 21, 23, 39, 40.

# CHECKLIST OF THE EXHIBITION

All measurements are in inches; height precedes width precedes depth. The artist's original titles, or alternate titles, are given in brackets.

1. **African Sculpture**, 1910, ill. p. 66
[*Congo Statuette*]
Gouache on board
13½ x 10½
Courtesy Forum Gallery, New York

2. **Composition with Four Figures**, 1910
Charcoal and pastel on paper
24¾ x 18¾
Collection of The Brooklyn Museum; Dick S. Ramsay Fund
Shown at the High Museum of Art and The Brooklyn Museum only

3. **Meditation**, 1910
Charcoal and graphite on paper
24½ x 17
Collection of the Greenville County Museum of Art; Museum purchase with funds provided by the Museum Association, Inc.

4. **Mexican Statuette**, 1910
Gouache on paper
29 x 24
Courtesy Forum Gallery, New York

5. **Portrait**, 1910-11
[*Cubist Portrait; Portrait of a Young Woman*]
Oil on canvas
18⅛ x 15¼
Collection of the Hood Museum of Art, Dartmouth College, Hanover, New Hampshire; Gift of Abby Aldrich Rockefeller

6. **Three Crystal Figures**, 1910
Oil on board
12¼ x 8¾
Courtesy Forum Gallery, New York

7. **Two Figures**, 1910, ill. p. 50
Oil on board
47½ x 24½
The Regis Collection, Minneapolis

8. **Brooklyn Bridge**, 1911
Oil on canvas
21½ x 12½
Collection of Joy S. Weber

9. **Chinese Ginger Jar**, 1911
Oil on canvas
17 x 22
Private Collection

10. **Connecticut Landscape**, 1911
Oil on panel
28 x 22¼
Courtesy Forum Gallery, New York

11. **Figure Study**, 1911, ill. p. 51
Oil on canvas
24 x 40
Collection of the Albright-Knox Art Gallery, Buffalo; C. W. Goodyear Fund, 1959

12. **Forest Scene**, 1911
Watercolor and graphite on paper
12½ x 8
Collection of the Whitney Museum of American Art, New York; Purchase with funds from the Felicia Meyer Marsh Purchase Fund and an anonymous donor

13. **The Geranium**, 1911
Oil on canvas
39⅞ x 32¼
Collection of The Museum of Modern Art, New York; Acquired through the Lillie P. Bliss Bequest, 1944

14. **Meditation**, 1911
Ink on paper
10⅝ x 6⅝
Collection of the Addison Gallery of American Art, Phillips Academy, Andover, Massachusetts

15. **Resting Figure**, 1911
Ink with gouache over graphite on paper
9 x 11⅞
Collection of Dr. Eugene A. Solow

16. **Trees**, 1911, ill. p. 53
Oil on canvas
28 x 22
Collection of Michael Scharf
Shown at the High Museum of Art and the Museum of Fine Arts, Houston only

17. **Women on Rocks**, 1911
Oil on canvas
18 x 12
Collection of Mrs. James F. Bing

18. **Brooklyn Bridge**, 1912, ill. p. 68
Watercolor, chalk, and charcoal on paper
19 x 24½
Collection of Lionel Kelly, England

19. **Dancers**, 1912
Watercolor on paper
24½ x 18¾
Collection of Lionel Kelly, England

20. **Dancers**, 1912, ill. p. 52
Gouache, pastel, and pencil on board
24¾ x 18⅝
Collection of Mr. and Mrs. Harvey Silverman, New York
Shown at the High Museum of Art, the Corcoran Gallery of Art, and The Brooklyn Museum only

21. **Figures in Landscape**, 1912
Oil on canvas
28 x 23
Collection of the Rose Art Museum, Brandeis University, Waltham, Massachusetts; Gift of Mrs. Max Weber and her children, Maynard and Joy, Great Neck, New York, in memory of Max Weber

22. **Music**, 1912
Oil and ink on board
24¼ x 18¼
The Regis Collection, Minneapolis

23. **Music**, 1912, ill. p. 70
Pastel on paper
23½ x 17¼
Private Collection

24. **New York**, 1912, ill. p. 67
Oil on canvas
21 x 25
Southwestern Bell Corporation Collection, St. Louis

25. **New York**, 1912, ill. p. 69
Watercolor and charcoal on paper
24½ x 19
Private Collection
Shown at the High Museum of Art, the Museum of Fine Arts, Houston, the Corcoran Gallery of Art, and the Albright-Knox Art Gallery only

26. **New York**, 1912
Watercolor and charcoal on paper
27 x 19
Collection of Lionel Kelly, England

27. **New York (The Liberty Tower from the Singer Building)**, 1912, ill. p. 53
[*The Woolworth Building*]
Oil on canvas
18 x 12¾
Collection of the Museum of Fine Arts, Boston; Gift from the Stephen and Sybil Stone Foundation
Shown at the High Museum of Art, the Museum of Fine Arts, Houston, and the Corcoran Gallery of Art only

28. **Order Out of Chaos**, 1912, ill. p. 52
Gouache on board
18½ x 12¼
Collection of Lionel Kelly, England

29. **Seated Figure**, 1912
Gouache on paper
15½ x 10
Baker/Pisano Collection

30. **Two Figures**, 1912
Pastel on board
27 x 13⅞
Private Collection

31. **Abstract Machine Forms**, 1913, ill. p. 72
Pastel on paper
24½ x 18¾
Collection of Mr. and Mrs. Leonard J. Plotch, Boca Raton, Florida

32. **Abstraction**, 1913, ill. p. 71
Pastel and collage on paper
24 x 18½
Collection of the New Britain Museum of American Art, Connecticut; Charles F. Smith Fund

33. **Abstraction**, 1913, ill. p. 71
[*Nude Descending a Staircase*]
Charcoal and pastel on paper
24⁷⁄₁₆ x 18⅝
Collection of the Yale University Art Gallery, New Haven, Connecticut; Gift of Walter L. Ehrich
Shown at the High Museum of Art, the Museum of Fine Arts, Houston, and the Corcoran Gallery of Art only

34. **Bather**, 1913, ill. p. 55
Oil on canvas
60⅝ x 24⅜
Collection of the Hirshhorn Museum and Sculpture Garden, Smithsonian Institution, Washington, D.C.; Gift of Joseph H. Hirshhorn, 1966

35. **Imaginary Portrait of a Woman**, 1913
[*Imaginative Portrait of a Woman*]
Oil on canvas
35 x 24
Collection of Natalie and Jerome Spingarn, in memory of Helen Miller Obstler
Shown at the Albright-Knox Art Gallery, The Brooklyn Museum, and the Los Angeles County Museum of Art only

36. **In the Woods**, 1913
Pastel on paper
24 x 17¾
Collection of the Weatherspoon Art Gallery, University of North Carolina at Greensboro; Dillard Collection
Shown at the High Museum of Art only

37. **Interior of the Fourth Dimension**, 1913, ill. p. 56
Oil on canvas
30 x 39½
Collection of the National Gallery of Art, Washington, D.C.; Gift of Natalie Davis Spingarn, in memory of her grandmother, Linda R. Miller
Shown at the High Museum of Art, the Museum of Fine Arts, Houston, and the Corcoran Gallery of Art only

38. **New York**, 1913, ill. p. 57
Oil on canvas
40⅝ x 32½
Thyssen-Bornemisza Collection, Lugano, Switzerland
Shown at the High Museum of Art and the Museum of Fine Arts, Houston only

39. **The Screen**, 1913, ill. p. 70
Pastel on paper
19 x 25
Private Collection

40. **Sunday Tribune**, 1913, ill. p. 58
Pastel on newsprint
23¾ x 16¾
Courtesy Forum Gallery, New York

41. **Tapestry #1**, 1913, ill. p. 73
Oil on canvas
40 x 30
Courtesy Forum Gallery, New York

42. **Women in Tents**, 1913, ill. p. 54
[*Woman and Tents*]
Oil on canvas
30 x 36
Private Collection, in memory of Helen M. Obstler

43. **Abstract Still Life**, 1914
Pastel on paper
21 x 17
Courtesy Forum Gallery, New York

44. **The Blue Vase**, 1914
Oil on canvas
24⅛ x 20⅛
Collection of The Newark Museum, New Jersey; Purchase (by exchange) 1986, gift of Emille Coles from the J. Ackerman Coles Collection, Mrs. Lewis Ballantyne, and the bequest of Lewis Bamberger

45. **Color in Motion**, 1914, ill. p. 59
Oil on board
20¾ x 16⅝
Collection of Michael Scharf
Shown at The Brooklyn Museum and the Los Angeles County Museum of Art only

46. **Figures**, 1914
Pastel on paper
24 x 18
Collection of Mr. and Mrs. Louis Regenstein
Shown at the High Museum of Art only

47. **Music Recital**, 1914, ill. p. 58
Gouache and pastel on paper
24 x 18
Fayez Sarofim Collection

48. **New York**, 1914, ill. p. 74
Oil on canvas
35½ x 29½
The Regis Collection, Minneapolis

49. **Athletic Contest**, 1915, ill. p. 63
[*Interscholastic Runners*]
Oil on canvas
40½ x 55¼
Collection of The Metropolitan Museum of Art, New York; George A. Hearn Fund, 1967 (67.112)
Shown at the High Museum of Art, the Museum of Fine Arts, Houston, the Corcoran Gallery of Art, the Albright-Knox Art Gallery, and The Brooklyn Museum only

50. **Avoirdupois**, 1915, ill. p. 75
Oil on canvas
21¼ x 18¼
Collection of the Baltimore Museum of Art; Mabel Garrison Siemonn Fund, in memory of her husband, George Siemonn, by exchange
Shown at the High Museum of Art, the Museum of Fine Arts, Houston, and the Corcoran Gallery of Art only

51. **Chinese Restaurant**, 1915, ill. cover
[*Memory of a Chinese Restaurant*]
Oil on canvas
40 x 48
Collection of the Whitney Museum of American Art, New York; Purchase

**52. Construction**, 1915, ill. p. 75
Oil on canvas
22⅞ x 27⅞
Collection of the Terra Museum of American Art,
Chicago
Shown at the Albright-Knox Art Gallery, The Brooklyn
Museum, and the Los Angeles County Museum of Art
only

**53. Cubist Figure**, 1915
Pastel on paper
24 x 18½
Collection of Natalie and Jerome Spingarn
Shown at the Corcoran Gallery of Art only

**54. New York at Night**, 1915, ill. p. 60
Oil on canvas
33⅞ x 20¹/₁₆
Collection of The Archer M. Huntington Art Gallery,
The University of Texas at Austin; Lent by James and
Mari Michener
Shown at the Albright-Knox Art Gallery, The Brooklyn
Museum, and the Los Angeles County Museum of Art
only

**55. New York Department Store**, 1915, ill. p. 61
[*An Idea of a Modern Department Store*]
Oil on canvas
46⅜ x 31
Collection of The Detroit Institute of Arts, Founders
Society Purchase, Mr. and Mrs. Walter Buhl Ford II Fund

**56. Night**, 1915, ill. p. 60
Oil on canvas
48 x 40¼
Sheldon Memorial Art Gallery, University of Nebraska–
Lincoln; NAA-Nelle Cochrane Woods Memorial
Collection
Shown at the Albright-Knox Art Gallery, The Brooklyn
Museum, and the Los Angeles County Museum of Art
only

**57. Rush Hour, New York**, 1915, ill. p. 62
Oil on canvas
36¼ x 30¼
Collection of the National Gallery of Art, Washington,
D.C.; Gift of the Avalon Foundation
Shown at the High Museum of Art, the Museum of Fine
Arts, Houston, the Corcoran Gallery of Art, and the
Albright-Knox Art Gallery only

**58. Spiral Rhythm**, 1915, ill. p. 72
Plaster
5⅜ x 3⅛ x 3⅛
Private Collection, in memory of Helen M. Obstler

**59. Friends**, 1916
Gouache and charcoal on paper
18¼ x 24
Courtesy Spanierman Gallery, New York

**60. Russian Ballet**, 1916, ill. p. 63
Oil on canvas
30 x 36
Edith and Milton Lowenthal Collection

**61. The Cellist**, 1917, ill. p. 49
Oil on canvas
20⅛ x 16⅛
Collection of The Brooklyn Museum; Gift of Mrs.
Edward Rosenberg

**62. Crystal Figure**, 1917
Pencil on paper
9¾ x 6½
Collection of the Minnesota Museum of Art, St. Paul;
Acquisition Fund Purchase

**63. Interior with Women**, 1917, ill. p. 76
Oil on canvas
18 x 23
Collection of Mr. and Mrs. Meredith J. Long

**64. The Meeting**, 1917, ill. p. 79
Pastel on paper
17 x 8
Courtesy Sheldon Ross Gallery, Birmingham, Michigan

**65. Primitive Head**, 1917
Oil on board
9½ x 6½
Collection of Michael and Ginny Abrams

**66. Seated Figure**, 1917
Gouache on paper
8½ x 5½
Courtesy Forum Gallery, New York

**67. Seated Figure**, 1917, ill. p. 81
Ink on paper
9¾ x 6⅛
Collection of the Fogg Art Museum, Harvard University,
Cambridge, Massachusetts; Bequest of Meta and Paul J.
Sachs

**68. Seated Woman**, 1917, ill. p. 80
Oil on canvas
40⅛ x 24¼
Collection of the Rose Art Museum, Brandeis University,
Waltham, Massachusetts; Gift of Mrs. Max Weber and
her children, Maynard and Joy, Great Neck, New York,
in memory of Max Weber

**69. The Two Musicians**, 1917, ill. p. 77
Oil on canvas
40⅛ x 30⅛
Collection of The Museum of Modern Art, New York;
Acquired through the Richard D. Brixey Bequest, 1944

70. **The Visit (A Family Reunion)**, 1917, ill. p. 83
Oil on board
36¼ x 30
Collection of the Corcoran Gallery of Art, Washington,
D.C.; Museum purchase through a gift of Mrs. Francis
Biddle
Shown at the High Museum of Art, the Museum of Fine
Arts, Houston, and the Corcoran Gallery of Art only

71. **Voices**, 1917, ill. p. 78
Oil on canvas
16 x 10
Collection of Joy S. Weber

72. **The City**, 1918, ill. p. 84
Pastel on paper
23⅝ x 18⅛
Collection of the Joslyn Art Museum, Omaha

73. **The Embrace**, 1918, ill. p. 82
Gouache on paper
8³/₁₆ x 5⅜
Collection of Dr. Harold and Elaine L. Levin

74. **Conversation**, 1919, ill. p. 64
Oil on canvas
42 x 32
Collection of the McNay Art Museum, San Antonio,
Texas; Museum purchase

75. **The Visit**, 1919
Oil on canvas
40 x 30
Edith and Milton Lowenthal Collection

# SELECTED BIBLIOGRAPHY

## BY THE ARTIST

**1910**

"Chinese Dolls and Modern Colorists." *Camera Work* (New York), no. 31 (July): 51.

"The Fourth Dimension from a Plastic Point of View." *Camera Work* (New York), no. 31 (July): 25.

**1911**

"To Xochipilli, Lord of Flowers." *Camera Work* (New York), no. 33 (January): 34.

**1913**

"The Filling of Space." *Platinum Print* (New York) 1 (December): 6.

"Introduction." In *Exhibition of Paintings and Watercolors at The Modern School.* New York: The Modern School.

**1914**

*Cubist Poems.* London: Elkin Mathews.

**1916**

*Essays on Art.* New York: William Edwin Rudge.

**1919**

"The New Humanity in Modern Art." *New York Call,* May 25, sec. 2, p. 2-3.

[Poems.] *Shriften* (New York) 5 (Fall): 5-9.

**1920**

[Essay.] *Shriften* (New York) 6 (Winter-Spring): 25-29.

[Poems.] *Shriften* (New York) 6 (Winter-Spring): 6-7, 12-21.

**1921**

[Essay.] *Shriften* (New York) 7 (Spring): 9-10.

[Poems.] *Shriften* (New York) 7 (Spring): 3-5.

**1925**

[Essay.] *Shriften* (New York) 8 (Winter): 25-32.

[Poems.] *Shriften* (New York) 8 (Winter): 19-24.

**1926**

*Primitives: Poems and Woodcuts.* New York: Spiral Press.

**1932**

"The Dead Bird." In *Twentieth Century Poetry.* Edited by Harold Monro. London: Chatto and Windus. 43-44.

**1934**

"Distortion in Modern Art." *The League* (New York) 6, no. 2: n. pag.

**1936**

"The Artist and His Audience." *Art Front* (New York) 2 (May): 8-9.

**1937**

[Letter to Franklin Delano Roosevelt.] *Art Front* (New York) 3 (October): 6-7.

**1941**

"An Artist Must be a Practical Dreamer." *Friday,* May 2, 18-20.

**1942**

"Rousseau As I Knew Him." *ARTnews* (New York) 41 (February 15): 17, 35.

**1945**

*Max Weber.* New York: American Artists Group.

[Speech, New Masses Cultural Awards Dinner.] *New Masses* (New York) 54 (February 6): 13.

**1946**

"A Letter from Max Weber." *Walker Art Center Activities* (Minneapolis) 2, no. 2: n. pag.

**1958**

*The Reminiscences of Max Weber.* Interview by Carol S. Gruber. Oral History Research Office, Columbia University, 1958.

**Archival Materials**

Weber Scrapbooks. Collection of Joy S. Weber, New Mexico.

Weber Papers. Microfilm nos. NY 59-6 through NY 59-10; N 69-82 through N 69-88; N 69-112. Archives of American Art, Smithsonian Institution, Washington, D. C.

## ABOUT THE ARTIST

Exhibition catalogues from 1981 to 1991 are cited in the Exhibition History, page 107.

**1910**

Burgess, Gelett. "The Wild Men of Paris." *Architectural Record* (New York) 27, no. 5 (May): 400-14.

Scott, Temple. "Fifth Avenue and the Boulevard Saint-Michel." *Forum* (New York) 44 (July-December): 665-85. Reprinted in Temple Scott. *The Silver Age.* New York: Scott and Seltzer, 1919. 143-74.

"'The Younger American Painters' and the Press." *Camera Work* (New York), no. 31 (July): 43-49.

**1911**

Hartmann, Sadakichi. "Structural Units." *Camera Work* (New York), no. 36 (October): 18-20.

**1912**

"Is Post-Impressionism a New Disease or a New Religion?" *Current Literature* (New York) 52, no. 5 (May): 584-88.

**1913**

Dana, John Cotton. "Paintings by Max Weber." *The Newark Museum Bulletin* (N.J.) 3, no. 1 (July): 1-5.

**1914**

Eddy, Arthur Jerome. *Cubists and Post Impressionism.* Chicago: A. C. McClurg.

**1916**

Brinton, Christian. *Impressions of the Art at the Panama-Pacific Exposition.* New York: John Lane Company.

"The Variegated Work of Max Weber." *Vanity Fair* (New York) 5, no. 6 (February): 65.

**1923**

Dasburg, Andrew. "Cubism—Its Rise and Influence." *The Arts* (New York) 4, no. 5 (November): 279-84.

Stieglitz, Alfred. "The Story of Weber." Alfred Stieglitz Archive. Collection of American Literature, Beinecke Rare Book and Manuscript Library, Yale University, New Haven, Connecticut.

**1925**

Gilliam, Florence. "Max Weber: Humanist." *Menorah Journal* (New York) 11, no. 6 (December): 580-82.

McBride, Henry. "Modern Art." *The Dial* (New York) 78 (April): 346-48.

**1930**

Barr, Alfred H., Jr. *Max Weber*. New York: The Museum of Modern Art.

Cahill, Holger. *Max Weber*. New York: The Downtown Gallery.

**1944**

Apollinaire, Guillaume. *The Cubist Painters*. New York: Wittenborn and Company.

Brian, Dorothy. "Last Word on Weber." *ARTnews* (New York) 42, no. 18 (February 1-14): 19, 28.

**1949**

Farber, Manny. "Weber Answers Questions." *ARTnews* (New York) 48, no. 1 (March): 22-24, 56.

Goodrich, Lloyd. *Max Weber*. New York: Whitney Museum of American Art.

**1950**

Reigner, Henrich. "Der Americanische Maler Max Weber." *Werk* (February): 55-61.

**1955**

Brown, Milton W. *American Painting from the Armory Show to the Depression*. Princeton, New Jersey: Princeton University Press.

Ingalls, Hunter. "Max Weber." Undergraduate thesis, Princeton University.

**1959**

Gerdts, William H. *Max Weber*. Newark, N.J.: The Newark Museum.

**1963**

Brown, Milton W. *The Story of the Armory Show*. Greenwich, Conn.: Joseph H. Hirshhorn Foundation.

Goodrich, Lloyd. *Pioneers of Modern Art in America: The Decade of the Armory Show, 1910-1920*. New York: Frederick A. Praeger.

Steichen, Edward. *A Life of Photography*. New York: Doubleday and Company in collaboration with The Museum of Modern Art. N. pag.

**1966**

Coburn, Alvin Langdon. *Alvin Langdon Coburn, Photographer: An Autobiography*. Edited by Helmut Gernsheim and Alison Gernsheim. New York: Frederick A. Praeger. 92.

Davidson, Abraham Aba. *Some Early American Cubists, Futurists, and Surrealists: Their Paintings, Their Writings, and Their Critics*. Ann Arbor, Mich.: UMI Information Dissertation Service.

**1967**

Zorach, William. *Art is My Life: The Autobiography of William Zorach*. Cleveland: World Publishing Company. 50, 57, 70-71, 132-35, 151, 158.

**1968**

Story, Ala. *Max Weber*. Santa Barbara, Calif.: Art Galleries, University of California.

Tarbell, Roberta K. "John Storrs and Max Weber: Early Life and Work." Master's thesis, University of Delaware, Newark.

**1969**

Walkowitz, Abraham. "A Tape Recorded Interview with Abraham Walkowitz: Conducted by Abram Lerner and Bartlett Cowdrey in New York on December 8 and 22, 1958." *Journal of the Archives of American Art* (Detroit) 9, no. 1 (January): 10-18.

**1970**

Cooper, Douglas. *The Cubist Epoch*. Los Angeles: Los Angeles County Museum; New York: The Metropolitan Museum of Art.

Cooper, Douglas; Gordon, Irene; Golson, Lucile M.; Hirschland, Ellen B.; and Katz, Leon. *Four Americans in Paris*. New York: Museum of Modern Art.

Leonard, Sandra. *Henri Rousseau and Max Weber*. New York: Richard L. Feigen Gallery.

**1971**

Henderson, Linda Dalrymple. "A New Facet of Cubism: The Fourth Dimension and Non-Euclidian Geometry Reinterpreted." *The Art Quarterly* (Detroit) 34, no. 4 (winter): 410-33.

"Interior of the Fourth Dimension." *The Baltimore Museum of Art Record* 1, no. 6 (February): 1.

Werner, Alfred. *Max Weber: Early Works on Paper*. Boston: Adelson Galleries.

**1973**

Homer, William Innes. "Stieglitz and 291." *Art in America* (New York) 61, no. 4 (July-August): 50-57.

**1974**

Nathanson, Carol Arnold. "The American Response in 1900-1913 to the French Modern Art Movements After Impressionism." Ph.D. diss., Johns Hopkins University.

**1975**

North, Phylis Burkley. *Max Weber: The Early Paintings (1905-1920)*. Ann Arbor, Mich.: UMI Information Dissertation Service.

Werner, Alfred. *Max Weber*. New York: Harry N. Abrams.

Zilczer, Judith. *The Aesthetic Struggle in America, 1913-1918: Abstract Art and Theory*. Ann Arbor, Mich.: UMI Information Dissertation Service.

**1976**

Lane, John R. "The Sources of Max Weber's Cubism." *Art Journal* (New York) 35, no. 3 (Spring): 231-36.

McCabe, Cynthia Jaffe. *The Golden Door, Artist-Immigrants of America: 1876-1976*. Washington, D.C.: Hirshhorn Museum and Sculpture Garden, Smithsonian Institution.

North, Percy. "Books in Review." Review of *Max Weber*, by Alfred Werner. *Art Journal* (New York) 36, no. 1 (Fall): 88-90.

Schwartz, Sanford. "Review of Books: Max Weber." Review of *Max Weber*, by Alfred Werner. *Art in America* (New York) 64, no. 8 (September): 53-57.

**1977**

Homer, William I. *Alfred Stieglitz and the American Avant-Garde*. Boston: New York Graphic Society. 57, 66-67, 74, 78, 86-87, 92, 97, 100-11, 114, 124, 126-38, 140-42, 146, 148, 153, 158, 164, 170, 215, 218, 259, 277, 285, 289, 296-97, 299-302.

Michner, James A. *Michner: The James A. Michner Collection, Twentieth Century American Painting*. Austin, Tex.: University Art Museum, University of Texas at Austin.

Moffatt, Frederick C. *Arthur Wesley Dow (1857-1922)*. Washington, D.C.: Smithsonian Institution Press.

**1978**

Levin, Gail. *Synchromism and American Color Abstraction, 1910-1925*. New York: Whitney Museum of American Art.

**1979**

Schwartz, Ellen. *Max Weber: Sculpture, Drawings and Prints*. New York: Forum Gallery.

**1980**

Bohn, Willard. "In Pursuit of the Fourth Dimension: Guillaume Apollonaire and Max Weber." *Arts Magazine* (New York) 54, no. 10 (June): 166-69.

Nadelman, Cynthia. "New York Reviews: Max Weber." *ARTnews* (New York) 79, no. 2 (February): 200.

*Paris and the American Avant-Garde, 1900-1925*. Contributions by Leslie Campbell, Ann Dumas, Deborah Fenton, Catherine Green, Louise Jackson, Cydna Mercer. Detroit: Detroit Institute of Arts.

Robbins, Diane Tepfer. "Max Weber." *Arts Magazine* (New York) 54, no. 6 (February): 27.

Rubenstein, Daryl R. *Max Weber: A Catalogue Raissoné of His Graphic Work*. Chicago: University of Chicago Press.

————. *Max Weber: Prints and Color Variations*. Washington, D.C.: National Collection of Fine Arts, Smithsonian Institution.

**1981**

D'Harnoncourt, Anne, and Celant, Germano. *Futurism and the International Avant-Garde*. Philadelphia: Philadelphia Museum of Art.

Hand, John Oliver. "Futurism in America." *Art Journal* (New York) 41, no. 4 (Winter): 337-42.

Marlor, C. S. "A Quest for Independence: The Society of Independent Artists." *Art and Antiques* (New York) 4, no. 2 (March-April): 75-81.

North, Percy. "Max Weber." *Arts Magazine* (New York) 55, no. 6 (February): 17.

**1982**

Henderson, Linda Dalrymple. "Mabel Dodge, Gertrude Stein and Max Weber: A Four-Dimensional Trio." *Arts Magazine* (New York) 57, no. 1 (September): 106-11.

North, Percy. "Album: Max Weber." *Arts Magazine* (New York) 57, no. 3 (November): 40-41.

**1983**

Henderson, Linda Dalrymple. *The Fourth Dimension and Non-Euclidian Geomtry in Modern Art*. Princeton, N.J., and Guildford, England: Princeton University Press. 60, 63-64, 109, 166-84, 197, 199, 203-4, 207, 209-10, 214-15, 217, 220-21, 231-33, 236, 339-41.

**1984**

Cohn, Sherrye. "Image and the Imagination of Space in the Art of Arthur Dove; Part II; Dove and the Fourth Dimension." *Arts Magazine* (New York) 58, no. 5 (January): 121-25.

North, Percy. "Turmoil at 291." *Archives of American Art Journal* (Washington, D.C.) 24, no. 1: 12-20.

Ricciotti, D. "The Revolution in Urban Transport: Max Weber and Italian Futurism." *American Art Journal* (New York) 16, no. 1 (Winter): 47-64.

**1985**

Lanchner, Carolyn, and Rubin, William. "Henri Rousseau and Modernism." In *Henri Rousseau*, by Roger Shattuck, Henri Behar, Michel Hoog, Carolyn Lanchner and William Rubin, 35-99. New York: The Museum of Modern Art.

**1986**

Flood, Suzette A. *American Modernist Painters in France: The Decade Before World War I*. Ann Arbor, Mich.: UMI Information Dissertation Service.

Henderson, Linda Dalrymple. "Mysticism, Romanticism and the Fourth Dimension." In *The Spiritual in Art: Abstract Painting 1890-1985*, edited by Maurice Tuchman, 219-37. New York: Abbeville.

**1987**

DiFederico, Frank. "Alvin Langdon Coburn and the Genesis of Vortographs." *History of Photography* (University Park, Penn.) 11, no. 4 (October-December): 276-77, 282-83.

**1989**

Messinger, L. M. "The Apollo in Matisse's Studio." *Metropolitan Museum of Art Bulletin* (New York) 47, no. 2 (Fall): 64.

# EXHIBITION HISTORY

The following documentation supplements that published in the retrospective catalogue *Max Weber: American Modern* (New York: The Jewish Museum, 1982). Exhibitions between 1910 and 1920 of Weber's cubist works are included in the Chronology, pp. 85-94.

## ONE-ARTIST EXHIBITIONS

### 1981
*Max Weber: Early Works on Paper, 1910-1918.* Forum Gallery, New York. January 2-31.

### 1982
*Max Weber: An Exhibition of Works.* Santa Fe East Gallery, New Mexico. August 13-September 20. Cat., text by A. S. King.

*Max Weber: American Modern.* The Jewish Museum, New York. October 5-January 16. Cat., text by Percy North. Traveled to Norton Gallery and School of Art, West Palm Beach, Florida; Marion Koogler McNay Art Institute, San Antonio; Joslyn Art Museum, Omaha.

*Max Weber: Work In All Media.* Forum Gallery, New York. October 6-November 4.

### 1983
*Max Weber: Pioneer of American Modernism.* Wichita Art Museum, Kansas. March 6-April 20. Brochure, text by Howard E. Wooden.

### 1984
*Max Weber: Lithographs and Woodcuts.* Forum Gallery, New York. December 8-January 9, 1985.

*Max Weber: Works on Paper 1908-1956.* Pembroke Gallery, Houston. December 15-January 28, 1985.

### 1986
*Max Weber: Cubist Vision—Early and Late.* Forum Gallery, New York. November 1-29. Brochure, text by Percy North.

### 1987
*Max Weber: An Exhibition of Works.* Santa Fe East Gallery, New Mexico. May 8-31.

### 1988
*Works on Paper.* Forum Gallery, New York. April 23-May 21.

### 1989
*Max Weber: Selected Works 1908-1932.* Feingarten Galleries, Los Angeles. April 7-June 1.

### 1990
*Max Weber: Selected Works 1908-1932.* Meredith Long & Co., Houston. January 31-March 3. Cat.

*Max Weber: Graphic Work.* Forum Gallery, New York. June 14-July 21.

### 1991
*Max Weber: The Figure, 1907-1957.* Forum Gallery, New York. March 7-April 6.

## SELECTED GROUP EXHIBITIONS

### 1981
*The Lawrence H. Bloedel Collection: A Loan Exhibition from the Whitney Museum of American Art and the Williams College Museum of Art.* The Society of the Four Arts, Palm Beach, Florida. February 14-March 15. Cat., intro. by Rick Stewart. Organized and circulated by International Exhibitions Foundation. Traveled to Oklahoma Museum of Art, Oklahoma City; The Arkansas Arts Center, Little Rock; Krannert Art Museum, Champaign, Illinois; Columbus Museum of Art, Ohio; Seattle Art Museum; Honolulu Academy of Arts.

*Drawing Acquisitions, 1978-1981.* Whitney Museum of American Art, New York. September 17-November 15. Cat., text by Paul Cummings.

*The Cubist Print.* The National Gallery of Art, Washington, D.C. October 18-January 3, 1982. Cat., texts by Burr Walden, Donna Stein. Traveled to University Art Museum, University of California, Santa Barbara; The Toledo Museum of Art.

*Modern Masters 1910-1981.* Aaron Berman Gallery, New York. [November]-December 5.

### 1982
*Abstract Drawings 1911-1981: Selections from the Permanent Collection.* Whitney Museum of American Art, New York. May 5-July 11. Cat., text by Paul Cummings.

*American Masters of the Twentieth Century.* Oklahoma Art Center, Oklahoma City. May 7-June 20. Cat., intro. by John I. H. Baur. Traveled to Terra Museum of American Art, Evanston, Illinois.

*20th Century Masters: The Thyssen-Bornemisza Collection.* The National Gallery of Art, Washington, D.C. May 30-September 6. Cat., text by William S. Lieberman. Organized by International Exhibitions Foundation. Traveled to Wadsworth Atheneum, Hartford; The Toledo Museum of Art; Seattle Art Museum; San Franscico Museum of Modern Art; The Metropolitan Museum of Art, New York; Phoenix Art Museum.

*Cubist Drawings 1907-1929.* Janie C. Lee Gallery, Houston. November 19-January 15, 1983. Cat., texts by Daniel Robbins, Margit Rowell.

### 1983
*The Great East River Bridge 1883-1983.* The Brooklyn Museum. March 19-June 19. Cat., texts by Williard C. Butcher, Michael Botwinick, Linda S. Ferber, Deborah Nevins, Barbara Head Millstein, David McCullogh, Albert Fein, Lewis Kachun, Steven S. Ross, Charles Reichenthal.

*Crossing Brooklyn Ferry, the River and the Bridge.* Museum of the Borough of Brooklyn. March 21-May 13.

*The Lane Collection: 20th Century Paintings in the American Tradition.* Museum of Fine Arts, Boston. April 13-August 7. Cat., texts by Theodore E. Stebbins, Jr., Carol Troyen. Traveled to San Franscico Museum of Modern Art; Amon Carter Museum, Fort Worth, Texas.

*Under Glass.* Washburn Gallery, New York. [July]-August 31.

*Maestri Americani della Collezione Thyssen-Bornemisza.* Vatican Museum, Rome. September 15-November 15. Cat., text by John I. H. Baur.

*Cubist Prints/Cubist Books.* Franklin Furnace, New York. October 15-December 3. Cat., texts by Donna Stein, Ron Padgett, George Peck. Traveled to Marion Koogler McNay Art Museum, San Antonio; Ball State University Art Gallery, Muncie, Indiana; Center for the Fine Arts, Miami, Florida; The Detroit Institute of Arts.

**1984**

*Advancing American Art: Politics and Aesthetics in the State Department Exhibition. 1946-48.* Montgomery Museum of Fine Arts, Alabama. January 10-March 4. Cat., texts by Margaret Lynne Ausfield, Virginia M. Mecklenburg. Traveled to The William Benton Museum of Art, Storrs, Connecticut; National Museum of American Art, Smithsonian Institution, Washington, D.C.; Terra Museum of American Art, Chicago.

*Maestri Americani della Collezione Thyssen-Bornemisza.* Villa Malpensa, Lugano, Switzerland. April 18-July 29. Cat., text by John I. H. Baur. Revision of 1983 exhibition at the Vatican Museum, Rome.

*Modern Masters from the Thyssen-Bornemisza Collection.* The National Museum of Modern Art, Tokyo. May 19-July 8. Cat., intro. by Anthony Burgess. Traveled to Kumamoto Prefectural Museum, Japan; Royal Academy of Arts, London; Germanisches Nationalmuseum, Nuremberg, Germany; Städtishe Kunsthalle, Dusseldorf, Germany; Palazzo Pitti, Florence; Musée d'arte modern de la Ville de Paris; Salas Pablo Ruiz Picasso, Biblioteca Nacional, Madrid; Palacio de la Virreina, Barcelona, Spain.

*"Primitivism" in 20th Century Art: Affinity of the Tribal and the Modern.* The Museum of Modern Art, New York. September 19-January 15, 1985. Cat., texts by Christian F. Feest, Philippe Peltier, Jean-Louis Paudrat, Kirk Varnedoe, Jack D. Flam, William Rubin, Sidney Geist, Donald E. Gordon, Ezio Bassani, Alan G. Wilkinson, Gail Levin, Laura Rosenstock, Jean Laude, Rosalind Krauss, Evan Maurer. Traveled to The Detroit Institute of Arts, Dallas Museum of Art.

*Into the Melting Pot: The Immigration of American Modernism (1909-1929).* Muscarelle Museum of Art, College of William and Mary, Williamsburg, Virginia. October 8-January 10, 1985. Cat., text by Percy North.

**1985**

*The Circle of Montparnasse: Jewish Artists in Paris, 1905-1945.* The Jewish Museum, New York. October 22-February 2, 1986. Cat., texts by Kenneth E. Silver, Romy Golan; contributions by Arthur A. Kohen, Billy Klüver, Julie Martin.

**1986**

*New Society of American Artists in Paris 1908-1912.* The Queens Museum, New York. February 1-April 6. Cat., texts by D. Scott Atkinson, William Innes Homer. Traveled to Terra Museum of American Art, Evanston, Illinois.

*The Advent of Modernism: Post-Impressionism and North American Art, 1900-1918.* High Museum of Art, Atlanta. March 4-May 11. Cat., texts by Peter Morrin, Judith Zilczer, William C. Agee. Traveled to Center for the Fine Arts, Miami, Florida; The Brooklyn Museum; Glenbow Museum, Calgary, Canada.

*Pioniere der Abstrakten Kunst aus der Sammlung Thyssen-Bornemisza.* Galerie Gmurzynska, Cologne, Germany. September 1-30.

*Modern Times: Aspects of American Art, 1907-1956.* Hirschl & Adler Galleries, New York. November 1-December 6. Brochure, intro. by Douglas Dreishpoon.

**1987**

*Modern American Realism: The Sara Roby Foundation Collection.* National Museum of American Art, Smithsonian Institution, Washington, D.C. January 30-April 14. Cat., texts by Virginia M. Mecklenburg, William Kloss.

**1988**

*Chicago Collects: Selections from the Collection of Dr. Eugene A. Solow.* The Art Institute of Chicago. May 3-August 21. Cat., text by Douglas W. Druick.

**1989**

*Over Here: Modernism, The First Exile 1914-1919.* David Winton Bell Gallery, Brown University, Providence. April 15-May 29. Cat., texts by Robert Brandfon, Kermit S. Champa, Kerry B. Herman and David C. Ogawa, Nancy R. Versaci, Judith E. Tolnick, Timothy Robert Rodgers, Patricia McDonnell, Jenny Anger and David A. Brenneman, James M. Baker.

*Revivals and Revitalizations: American Pastels in The Metropolitan Museum of Art.* The Metropolitan Museum of Art, New York. October 17-January 14, 1990. Cat., texts by Doreen Bolger, Mary Wayne Fritzsche, Jacqualine Hazzi, Gail Stavitsky, Mary L. Sullivan, Marc Vincent, Elizabeth Wylie, Marjorie Shelley.

*American Modernist Landscapes: The Spirit of Cézanne.* Linda Hyman Fine Arts, New York. November 4-December 22. Brochure, text by Linda Hyman.

**1990**

*Of Time and the City: American Modernism from the Sheldon Memorial Art Gallery.* Sheldon Memorial Art Gallery, Lincoln, Nebraska. January 9-March 11. Cat., text by Daphne Anderson Deeds. Traveled to J. B. Speed Art Museum, Louisville, Kentucky; Paine Art Center and Arboretum, Oshkosh, Wisconsin; The Art Museum at Florida International University, Miami; Crocker Art Museum, Sacramento, California; The Society of the Four Arts, Palm Beach, Florida; Louisiana Arts and Science Center, Baton Rouge; Tacoma Art Museum; Cummer Gallery of Art, Jacksonville, Florida; Terra Museum of American Art, Chicago.

*Nineteen Americans.* Forum Gallery, New York. February 7-March 10. Brochure, text by Terrance Dewsnap.

*Three Americans: Avery, Soyer, and Weber.* Riva Yares Gallery, Scottsdale, Arizona. March 15-April 14. Cat.

*Gertrude Stein: The American Connection.* Sid Deutsch Gallery, New York. November 3-December 8. Cat., text by Gail Stavitsky. Traveled to Terra Museum of American Art, Chicago; University Art Museum, University of Minnesota, Minneapolis; The Butler Institute of American Art, Youngstown, Ohio; Kalamazoo Institute of Arts, Michigan.

**1991**

*The Landscape in Twentieth Century American Art: Selections from The Metropolitan Museum of Art.* The Philbrook Museum of Art, Tulsa. April 14-June 6. Traveled to Center for the Fine Arts, Miami, Florida; Joslyn Art Museum, Omaha; Tampa Museum of Art.

*Maleri im Prisma: Freundeskreis Sonia und Robert Delaunay.* Galerie Gmurzynska, Cologne, Germany. April 28-July 26. Cat.

*Painting a Place in America: Jewish Artists in New York, 1900-1950. A Tribute to the Educational Alliance Art School.* The Jewish Museum at The New-York Historical Society. May 16-September 29. Cat., edited by Norman L. Kleeblatt and Susan Chevlowe.

*Summer.* Forum Gallery, New York. June 20-July 31.

# PHOTO CREDITS

E. Irving Blomstrann: cat. 32

Barney Burstein: cat. 68

Geoffrey Clements: fig. 14, cover, cat. 31

Rick Harman: cats. 42, 58

James Hart: figs. 1, 8, 11-13, 19, 22, 24-26, 27, 29, 31-37, 39, 41, 42

George Holmes, Archer M. Huntington Art Gallery: cat. 54

Thomas Loonan: fig. 9

Chisholm Rich and Associates: cat. 63

Eric Smith: cat. 64

Lee Stalsworth: cat. 34

Joseph Szaszfai: fig. 15

University photographer, University of Reading, England: figs. 28, 40; cats. 18, 28

James M. Via: fig. 17

Ed Watkins: cats. 1, 20, 39-41

Graydon Wood: cat. 22